IMAGES
of America

PRINCE GEORGE'S
COUNTY
MARYLAND

About the Authors

Katharine D. Bryant lives in College Park in a Prince George's County Historic Site on Columbia Avenue that was built by her great uncle, George Johnston, c. 1888. Her great-grandfather was John Oliver Johnson, who founded College Park in 1890 on 125 acres of land purchased from Ella Calvert Campbell and lived in Campbell's house at the corner of Columbia Avenue and College Avenue. The house has been torn down.

Katharine was an investigative political newspaper reporter for four newspapers and an editor for Duke Power Company in North Carolina before moving back to College Park. She won 33 awards for reporting and photography from international, national, state, and regional organizations, including several from the North Carolina Press Association.

A freelance photographer and writer, in 1991, she was the photographer for Queen Elizabeth's visit to Mount Vernon. She had three photography exhibits of her landscapes at National Colonial Farm in Accokeek, including one of her aerial photography of historic sites in Southern Maryland and Virginia. Katharine has done photography for Congressman Steny Hoyer, the 21st District Democrats, County Councilman Jim Estepp, Edison Electric Institute, Crescent Cities Jaycees, Northeast Utilities in Connecticut, Tenneco in Houston, The Pantry convenience stores in Atlanta, and Calvary House in Washington, plus writing for USF&G Insurance in Baltimore, the *Delmarva Farmer* newspaper in Easton, and a lobbyist. She is a member of the Prince George's County Historical & Cultural Trust.

Donna L. Schneider of Upper Marlboro is an asset management officer with the Export-Import Bank of the United States (Ex-Im Bank) in Washington, D.C. Ex-Im Bank is an independent agency of the federal government that lends money to support U.S. exports abroad. With Ex-Im Bank since August 1989, Donna manages the portfolio of sovereign defaulted assets and monitors projects in industries around the world.

Donna has done graduate work toward an MBA degree in international business, concentrating on international banking. She graduated summa cum laude and as the valedictorian in June 1988 from Strayer (College) University with a B.S. in accounting and an A.A. in marketing. She attended Strayer on a full-tuition academic Presidential Scholarship. She also graduated from Eleanor Roosevelt Science and Technology Center in 1985.

Donna is the treasurer and past secretary of Prince George's County Historical & Cultural Trust. She was the treasurer for the Friends of the Largo-Kettering Library and has served as the president and secretary of the Kettering Civic Federation. On weekends, she volunteers for the College Park Aviation Museum.

IMAGES
of America

PRINCE GEORGE'S
COUNTY
MARYLAND

To Karen –
Donna Schneider

Katharine D. Bryant and Donna L. Schneider
on behalf of the Prince George's County
Historical & Cultural Trust

ARCADIA

ISBN 0-7385-0265-0

Published by Arcadia Publishing,
an imprint of Tempus Publishing, Inc.
2 Cumberland Street
Charleston, SC 29401

Printed in Great Britain.

Library of Congress Catalog Card Number: 99-066582

For all general information contact Arcadia Publishing at:
Telephone 843-853-2070
Fax 843-853-0044
E-Mail arcadia@charleston.net

For customer service and orders:
Toll-Free 1-888-313-BOOK

Visit us on the internet at http://www.arcadiaimages.com

About the Prince George's County Historical & Cultural Trust

Prince George's County was one of the first counties in Maryland to respond to a 1966 state law encouraging the creation of local agencies dedicated to the preservation of historic properties. The Prince George's County Historical & Cultural Trust ("Trust"), established in 1968, is a non-profit charitable body consisting of 15 members appointed by the county executive and confirmed by the county council to four-year terms. The Trust participated in developing a master plan for historic preservation and holds a permanent seat on the county's Historic Preservation Commission. The Trust may acquire and hold real and personal property; accept gifts, bequests, or endowments; and solicit funds for its programs under Section 501 (c) (3) of the Internal Revenue Code.

Activities of the Trust include the identification and protection of the county's historic sites, the encouragement of restoration efforts, the acquainting of the public with the county's rich cultural heritage through lectures and workshops, the awarding of grants for preservation projects, and the endowing of the annual Margaret W. Cook Award for historic preservation at the University of Maryland.

Friends of Preservation was created in 1982 to support preservation programs of the Trust through dues and volunteer activities. Associate membership privileges include non-voting participation at Trust meetings, invitations to Trust-sponsored events, a quarterly newsletter "Friends of Preservation," and discounts on items from the Newel Post, a recycling center of architectural elements salvaged from old buildings or accepted as donations.

CONTENTS

DISCLAIMER

This book does not pretend to be a comprehensive history of Prince George's County. We set out to make it an informative and interesting collection of family snapshots and old photographs from more than 50 years ago that, for the most part, have not been published elsewhere.

Although the photographs may seem like a random collection, and in part they are, we sent numerous letters to various organizations, municipalities, and people who might have interesting old photographs that capture the way life used to be in the county. Responses were varied, and in the end, we were limited by what photographs existed and what people were willing to give us. All the photographs used are copies of originals.

After publication, we will donate most of the photographs to the Prince George's County Historical Society's photo archives at Marietta Mansion in Glenn Dale for preservation. Many old photographs are in private collections that have already left the county. We felt it was time to collect copies of as many as we could to preserve.

Because there were a sizable number of photographs left over, we plan to publish a second book in a few years. Anyone who has old photographs from Prince George's County is welcome to donate copies of the originals for future publication. Please send professional photographic copies only to Katharine D. Bryant at 7406 Columbia Avenue, College Park, Maryland, 20740, or call her at 301/927-2931 for more information.

PRINCE GEORGE'S COUNTY HISTORY AND HERITAGE

ESTABLISHMENT OF THE COUNTY

In 1634, Governor Leonard Calvert founded Maryland's first settlement at St. Mary's City. The Maryland colony flourished and enjoyed peaceful relations with the neighboring Piscataway and Susquehannock tribes. By 1695, 1,600 to 1,700 people left the original settlement to live on farms and plantations lining both the Patuxent and Potomac Rivers. Governor Francis Nicholson and the General Assembly agreed that the area deserved self-government. On St. George's Day, April 23, 1696, a new county was established, named for Prince George of Denmark, the husband of Princess Anne, heir to England's throne. The first county seat was at Charles Town on the Patuxent, a port town established in 1683 by the General Assembly. The new Prince George's County extended southward to the Charles County line, north toward the Pennsylvania border, and marked Maryland's western frontier. It remained the frontier until 1748, when the westernmost regions were granted their own government, and Prince George's County's northern boundary became basically the line it is today.

In 1692, the Church of England became the established church of the Maryland colony through an Act of the General Assembly. In 1696, Prince George's County had two parishes established within its boundaries: St. Paul's and Piscataway (or King George's). There was already a church at Charles Town that was used as a meeting place for the county court until a new courthouse was completed in 1698. In Piscataway Parish, the first church was built in 1696 at the site of the present-day St. John's Church, Broad Creek.

EIGHTEENTH CENTURY

Prince George's County was gradually settled by Europeans coming as free men and indentured servants. Landowners turned to African slave labor for the operation of their plantations. In 1706, the General Assembly passed an Act of the Advancement of Trade, reestablishing Charles Town and establishing five more port towns: Queen Anne, Nottingham and Mill

Town on the Patuxent, Marlborough on the Western Branch of the Patuxent, and Aire at Broad Creek on the Potomac. A year later, a supplementary Act established the Town of Piscataway at the head of Piscataway Creek. These trading centers grew; merchants built stores selling everything from yard goods and shoe buckles to grubbing hoes, sugar, and salt; lawyers and doctors established practices; innkeepers acquired licenses to sell liquor and opened their doors to travelers and residents alike.

"Upper" Marlborough (distinguishing it from "Lower" Marlborough in Calvert County), developed more rapidly than other towns. By 1718, Upper Marlborough became such an active center that inhabitants petitioned to have the court proceedings moved from Charles Town. The county court met for the first time in Upper Marlborough in 1721. Until the early twentieth century, Upper Marlboro (as it became) was the commercial, political, and social center of Prince George's County and remains its county seat.

Tobacco created the wealth that built fine plantation homes, educated the children of leading families, supported the work of religious faiths, and fostered the arts such as theater, dance, and music. That wealth provided the means to enjoy leisure activities such as fox hunting and horse racing and enabled planters to devote such care to their horses and their breeding that Prince George's County became the cradle of American thoroughbred racing, a sport still a part of our county today. Tobacco provided a modest livelihood for small farmers and served as legal tender for debts.

Prince Georgeans organized county committees to assist the Revolutionary effort and sent many of their sons to fight for independence. John Rogers of Upper Marlborough sat in the Continental Congress, which in July 1776 voted to make the colonies free and independent states. In September 1787, Daniel Carroll, also of Upper Marlborough, was one of the 39 men who signed the Constitution for the United States. In April 1788, four distinguished Prince Georgeans attended the Ratification Convention in Annapolis and voted unanimously to ratify the Constitution. In 1790, when the Congress in Philadelphia decided to locate the new federal capital along the Potomac River, Prince George's County ceded most of the land necessary to establish the District of Columbia. Today, the Capitol, the White House, and the Supreme Court building stand on Prince George's County land. With the Declaration of Rights of 1776, American religion began an independent life in the new nation. John Carroll of Upper Marlborough became the first Roman Catholic bishop in the United States, and Thomas John Clagett of Croom became the first Episcopal bishop consecrated in this country.

Nineteenth Century

In August 1814, during the War of 1812, the British sailed up the Patuxent to Benedict and began a march through Nottingham, Upper Marlborough, Long Old Fields (now Forestville), past the new Addison Chapel, to Bladensburg, where they defeated an ill-prepared American army and burned many public buildings in Washington. On their way back to their ships, they seized Dr. William Beanes of Upper Marlborough and took him to Baltimore. Francis Scott Key was on a mission to plead for Dr. Beanes's release when he witnessed the bombardment of Fort McHenry and wrote the poem that became our national anthem, "The Star-Spangled Banner."

The early 1800s brought changes to the county. Although tobacco remained predominant, farmers began to experiment with new crops on land worn out by continuous tobacco cultivation. In 1817, the first county agricultural society in Maryland was founded in Prince George's County. Agriculturalists such as Horace Capron, Dr. John Bayne, and Charles B. Calvert attracted national attention with their agricultural experimentation. Charles Calvert's efforts established the nation's first agricultural research college (now the University of Maryland at College Park) in 1858.

The Industrial Revolution crept into northern Prince George's County with the

establishment of cotton mills at Laurel in the 1820s and the Muirkirk Iron Furnace near Beltsville in the 1840s. In the early nineteenth century, the first turnpike was constructed using about 14 miles of convenient, nearly straight county roadway to link Washington and Baltimore. The prominence of the turnpike was short-lived because in 1835 the Baltimore and Ohio Railroad was completed between Baltimore and Washington. The railroad brought momentous change to the area, altering traditional methods of travel, transforming small crossroad communities into population centers and, eventually, potential sites for suburban expansion. The railroad provided the right-of-way on which Samuel F.B. Morse strung the country's first telegraph line in 1844. The success of the Baltimore and Ohio Railroad also stimulated the planters of Southern Maryland to seek construction of another railroad through rural southeastern Prince George's County to provide easy access to the Baltimore market.

Two Prince Georgeans achieved national political distinction in the early nineteenth century. Gabriel Duvall of Marietta sat on the United States Supreme Court and William Wirt, a Bladensburg native, served for 12 years as United States attorney general. During the nineteenth century, five distinguished Prince Georgeans served as the governor of Maryland: Robert Bowie of Nottingham, Samuel Sprigg of Northampton, Joseph Kent of Rose Mount, Thomas G. Pratt of Upper Marlborough, and Oden Bowie of Fairview.

In the mid-1800s, agriculture diversified, industry developed, the fisheries off the Patuxent and Potomac yielded rich harvests, steamboats plied the Patuxent linking the county to Baltimore, trains ran regularly between Baltimore and Washington, and tobacco remained a profitable enterprise. More tobacco was grown here than in any other Maryland county, and more slaves tilled the fields here than in any other place in the state. The labor of the county's African-American community, 90 percent of it slave in 1860, helped guarantee that prosperity.

Prince George's County was divided during the Civil War from 1861 to 1865. Although Maryland made no move to secede from the Union, there was great sympathy in the county for the Southern cause. The prominent county families were slave holders and very Southern-oriented, and many of their sons fought for the Confederacy. Many slaves in Prince George's County fled to freedom in the District of Columbia when slavery was abolished there in 1862. Emancipation took effect in Maryland in January 1865 and brought an end to the old plantation system.

Soon after, small African-American communities began to develop, such as Rossville near the Muirkirk Furnace, Chapel Hill near Fort Washington, and communities near Woodville, Queen Anne, and Upper Marlborough. Each community was centered around a place of worship, usually Methodist. The newly emancipated people proceeded to build homes while working in the iron furnaces, railroad construction, and, principally, farming. With the assistance of the Freedmen's Bureau, these communities soon had schoolhouses and teachers, beginning the significant movement toward African-American education.

Agriculture remained the predominant way of life. Tobacco continued to be the most important crop, and the large plantations by no means vanished. But in the last decades of the nineteenth century, small farms growing tobacco and other crops played a larger role in the county's economic life. Between the end of the Civil War and the turn of the century, many new smaller farms were operated by freed blacks, but many more were owned by newcomers. As our agricultural population grew, so did the importance of local commerce in the overall economic picture.

As Washington grew to a major capital, the county accommodated the increasing number of federal employees and city workers. The new branch line of the Baltimore and Potomac Railroad opened in 1872, joining the main line to Southern Maryland at the Bowie junction and creating a second rail link between Washington and Baltimore. In the 1880s and 1890s, residential communities were developed north of Washington along both of the railroad lines and included such towns as Hyattsville, Takoma Park, Riverdale Park, Charlton Heights (now Berwyn Heights), College Park, Glenn Dale, and Bowie.

TWENTIETH CENTURY

As the twentieth century began, new types of transportation, like the streetcar and the Washington, Baltimore and Annapolis electric railroad, offered more opportunities for residential development. Towns such as Mount Rainier, Colmar Manor, Cottage City, Brentwood, Capitol Heights, and Seat Pleasant began to develop. Several African-American communities, such as Fairmount Heights, Lincoln, and North Brentwood, were established and attracted members of a growing group of black professionals.

The new science of aviation made history in Prince George's County with the establishment of College Park Airport in 1909 and military flight instruction there by Wilbur Wright. In 1941, John Greene established the Columbia Air Center, the first African-American-owned airport in the county, on a field near Croom. The county's prominence in aviation was reinforced by the construction, in 1942, of Andrews Air Force Base. Other large federal installations moved into the county: Beltsville Agricultural Research Center, consisting of over 10,000 acres purchased by the U.S. government between 1910 and 1940; Patuxent Wildlife Research Center established in 1936; and the Suitland Federal Center established in 1942.

Farming remained the way of life for many in the vast rural areas, but year by year the percentage of the population earning their livelihood through agriculture declined as the denser suburban population close to Washington grew. New communities began to appear as the increasing use of the automobile allowed for further residential development; Cheverly, Greenbelt, District Heights, New Carrollton, and Glenarden are examples of this trend.

Today, Prince George's County is a place where men and women of all religions, races, national origins, and economic positions live and work. The county is rich also in designated historic sites due to a strong preservation culture. The new millennium promises the continued pursuit of a new and active image for Prince George's County through the development of professional-educational establishments, the revitalization of older communities, and the preservation of the county's proud heritage of historic resources and rural areas.

This history is based on *Prince George's County: A History*, prepared for the 1981 Historic Sites and Districts Plan by Alan Virta. It has been revised, expanded, and updated by Susan Pearl of the Maryland-National Capital Park & Planning Commission Historic Preservation Section, 1999.

One

FARMING

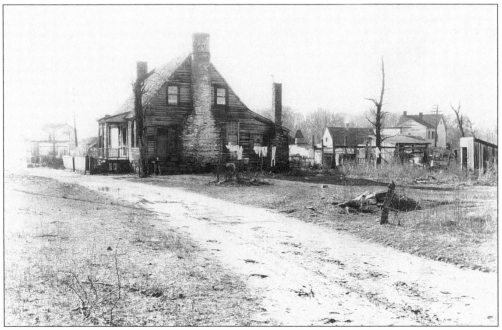

This is a photograph of the Old Clement's Farm in Bladensburg. (Submitted by Susan Reidy, historian for the Natural and Historical Resources Division of Maryland-National Capital Park & Planning Commission.)

Ferndale Farm near T.B. is shown in 1940. The photograph was taken from the gap between the Frank A. Robinson farm and the property of Dick and Ernest Robertson. (Submitted by Mary R. Conner of Accokeek.)

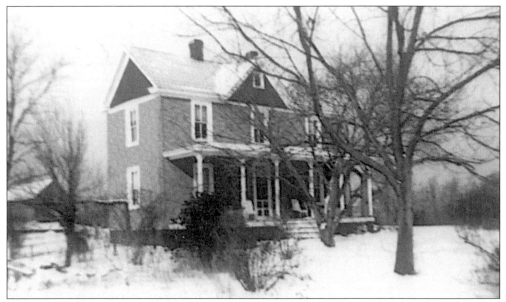

The home of the Robinson family on the Ferndale Farm near T.B. was photographed in December 1947. The home was built by Frank A. Robinson in 1912 and was demolished in 1975. (Submitted by Franklin A. Robinson Jr. of Benedict; courtesy of the Robinson-Via Family Papers, NMAH, Archives Center, Smithsonian Institution.)

A view of the main house on the Ferndale Farm was taken in June during the late 1940s. The wheat crop has been cut and is waiting to be thrashed. (Submitted by Franklin A. Robinson Jr. of Benedict; courtesy of the Robinson-Via Family Papers, NMAH, Archives Center, Smithsonian Institution.)

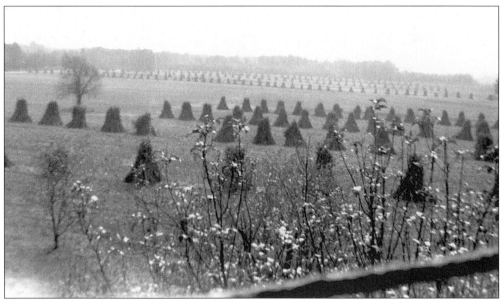

Corn shocks line the fields of the Ferndale Farm, home of the Robinson family, near T.B. in the late 1940s. (Submitted by Franklin A. Robinson Jr. of Benedict; courtesy of the Robinson-Via Family Papers, NMAH, Archives Center, Smithsonian Institution.)

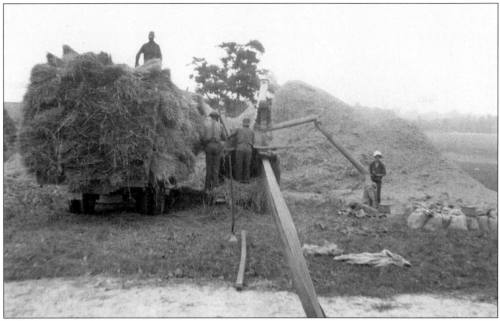

William and Jim Gross harvest tobacco on the Ferndale Farm, the home of the Robinson family, near T.B. in August 1948. (Submitted by Franklin A. Robinson Jr. of Benedict; courtesy of the Robinson-Via Family Papers, NMAH, Archives Center, Smithsonian Institution.)

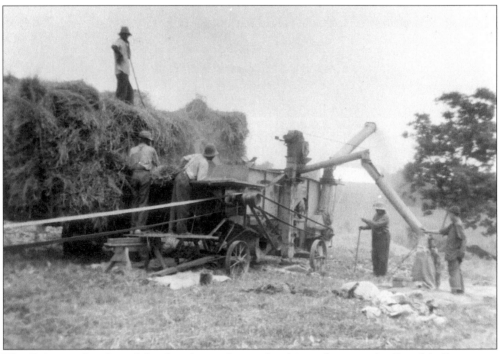

The Robinson family and farmhands are shown thrashing wheat on the Ferndale Farm near T.B. in July 1949. (Submitted by Franklin A. Robinson Jr. of Benedict; courtesy of the Robinson-Via Family Papers, NMAH, Archives Center, Smithsonian Institution.)

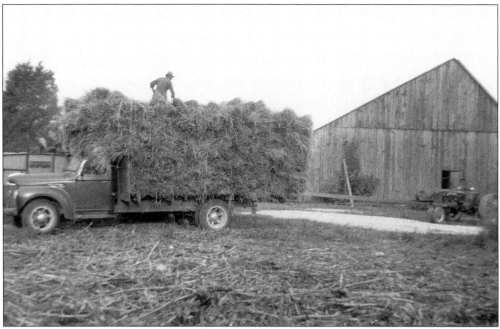

Farmhands load wheat to be thrashed on the Ferndale Farm, the home of the Robinson family, near T.B. in June 1949. (Submitted by Franklin A. Robinson Jr. of Benedict; courtesy of the Robinson-Via Family Papers, NMAH, Archives Center, Smithsonian Institution.)

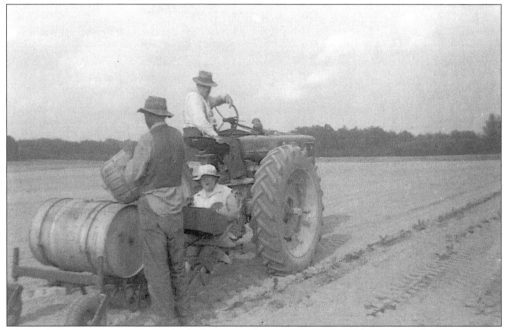

The Robinsons were photographed planting tobacco on the Ferndale Farm in the early 1950s. Frank A. Robinson is driving the tractor, and his wife, Elizabeth B. Robinson, is riding the planter. Norris Gross is loading tobacco plants. (Submitted by Franklin A. Robinson Jr. of Benedict; courtesy of the Robinson-Via Family Papers, NMAH, Archives Center, Smithsonian Institution.)

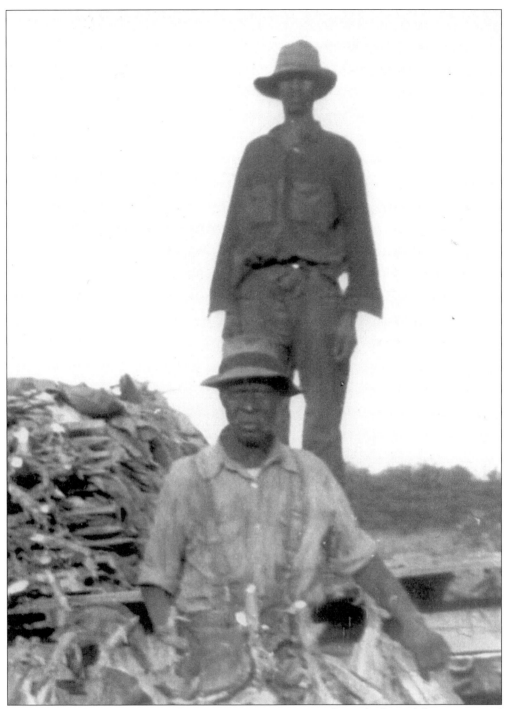

Tobacco was the primary crop of Prince George's County in the early days of the county, and farms were located along the Potomac River so the crop could be easily transported. This photograph shows two members of the Gross family getting in the tobacco on the Ferndale Farm, home of the Robinson family, in T.B. in the 1940s. (Submitted by Mary R. Conner of Accokeek.)

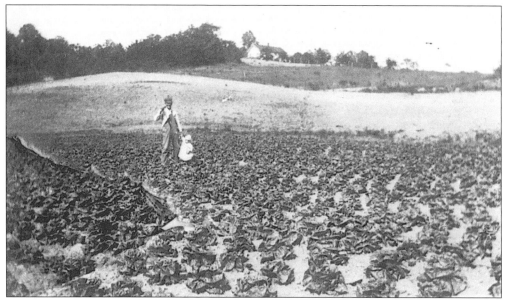

Taken in 1923, this photograph shows Silas Potts Newton (1870–1956) standing in a field of cabbage and holding the hand of a grandchild. In the background is the home that he purchased in 1914, which is now Colebrook Avenue and Blacksnake Drive in Hillcrest Heights. In 1914, he paid $14.07 in property taxes. (Submitted by Barbara Harris Herbert of Coltons Point.)

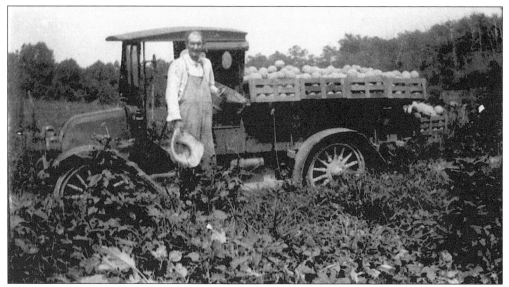

This 1923 photograph shows Silas Potts Newton standing beside a truckload of cantaloupes that were grown on his farm. In land records, the farm is located in "W. Barnaby," which is now Hillcrest Heights. Mr. Newton moved to somewhere on Morris Road, Anacostia, Washington, D.C. in 1891 and drove horse-drawn streetcars downtown for 22 years before moving to Maryland and farming full time. (Submitted by Barbara Harris Herbert of Coltons Point.)

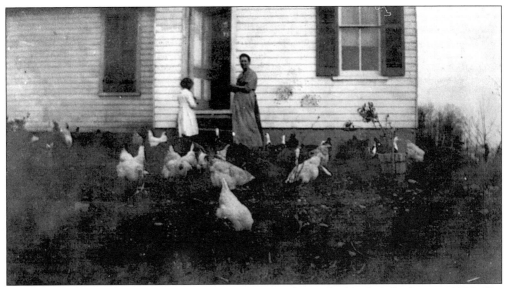

Ida Belle (Snellings) Newton (1870–1943) is shown at home feeding her chickens in 1923. She is the wife of Silas Potts Newton. The child is Ida Mae Newton (1912–1999), the youngest of six children who lived on the farm. (Submitted by Barbara Harris Herbert of Coltons Point.)

Large farms were often divided into smaller holdings that were farmed by tenants. Modest dwellings, such as this tenant house associated with The Cottage near Upper Marlboro, housed the families who worked the land both for their own livelihood and for the profit of the landowner. (Submitted by the Prince George's County Historical & Cultural Trust.)

From the mid-eighteenth to the mid-nineteenth centuries, almost half the population of Prince George's County was slaves. They were the source of labor that made the county's vast tobacco production possible. Generally, slaves were housed in small cabins, most of which have not survived. This small building at Brookefield of the Berrys plantation in Naylor may once have been slave quarters. Brookefield of the Berrys is a historic site. (Submitted by the Prince George's County Historical & Cultural Trust.)

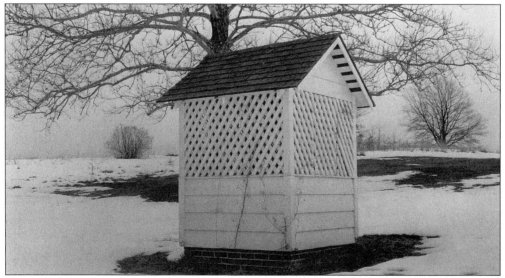

Wells were critical sources of fresh water on many farms. This well house at The Cottage near Upper Marlboro is a typical example of the small structures built to enclose and protect wells. The Cottage is a historic site. (Submitted by the Prince George's County Historical & Cultural Trust.)

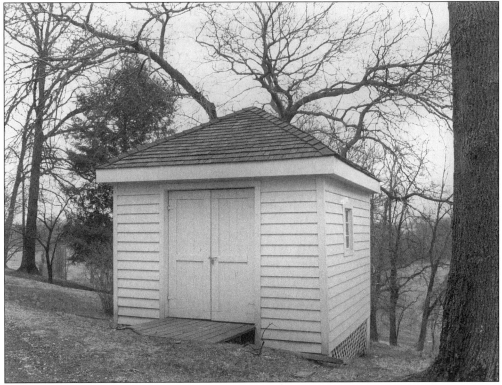

Fresh water was also available from springs. Spring houses like this one at Bleak Hill near Upper Marlboro were built to protect the spring and provide a cool environment for storing dairy and other products. Bleak Hill is a historic site. (Submitted by the Prince George's County Historical & Cultural Trust.)

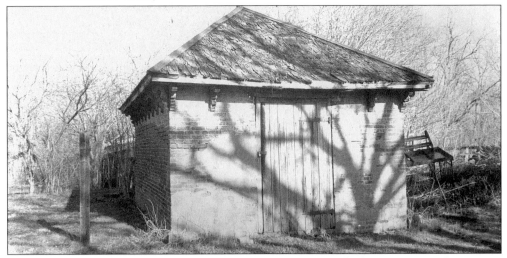

Before the advent of the refrigerator and freezer, meat was smoked to preserve it for storage. Meat was hung over smoky fires in smokehouses, like this example at Hazelwood in Queen Anne in the Mitchellville vicinity. The Hazelwood smokehouse is unusual, however, since part of the building was also used as a privy. Hazelwood is a historic site. (Submitted by the Prince George's County Historical & Cultural Trust.)

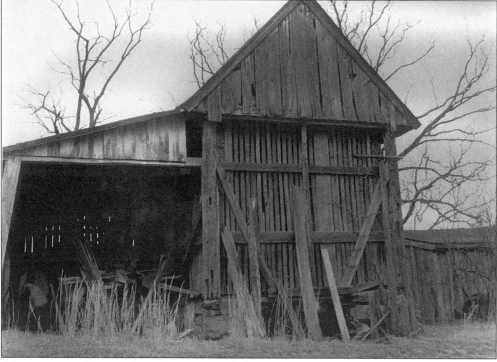

After corn was harvested, a place was needed to store it and allow it to dry for later use in feeding livestock. Corn cribs were narrow buildings with slatted sides designed to maximize air circulation around the drying corn stored within. This example is at Belleview, a historic site in Friendly. (Submitted by the Prince George's County Historical & Cultural Trust.)

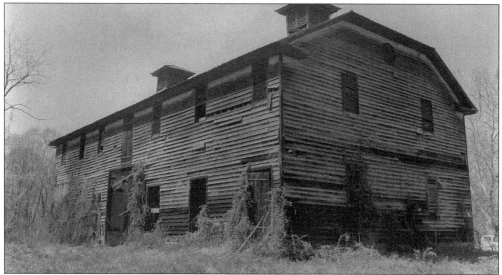

Although tobacco was the county's primary crop, farmers in the nineteenth century raised increasing amounts of corn, wheat, and livestock. This diversification led to the construction of multipurpose barns that were designed to house animals and store crops. The Seton Belt Barn in Mitchellville is an exceptional example. (Submitted by the Prince George's County Historical & Cultural Trust.)

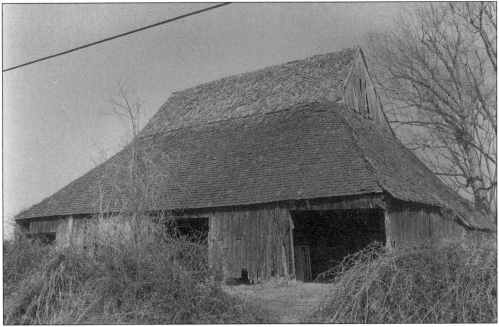

Throughout most of the county's agricultural history, tobacco has been the principal crop. Tobacco barns designed specifically for the drying and curing of tobacco were widespread. Fewer and fewer tobacco barns survive today. The Warington Barn at Newton-White Farm, a historic site in Mitchellville, is the best surviving example in the county. (Submitted by the Prince George's County Historical & Cultural Trust.)

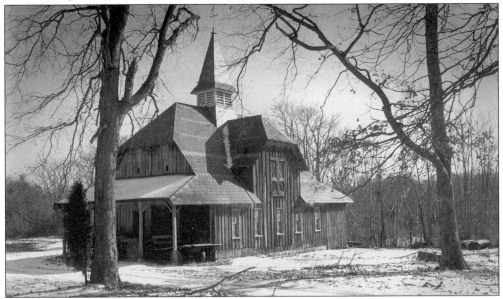

Prior to the machine age, horses and oxen were vital to both transportation and agriculture. While farms of modest means housed these animals in barns, wealthier landowners often built large stables specifically for their horses. This stable, at Villa de Sales in Aquasco, is a uniquely elaborate example. Villa de Sales is a historic site. (Submitted by the Prince George's County Historical & Cultural Trust.)

Two

ROADS

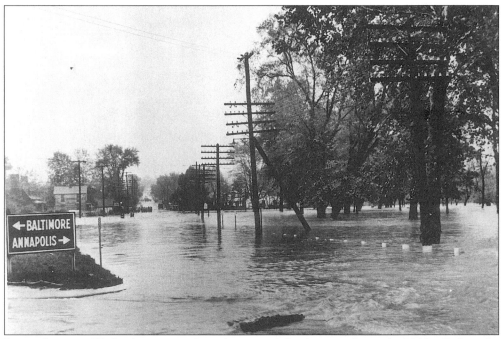

Peace Cross in Bladensburg was often the site of flooding in the early 1900s. Before the Anacostia River Flood Control Project in 1954, the Northeast Branch of the Anacostia River would overflow its banks and inundate the intersection of Route 1 and Route 50 (now Route 450). Sometimes, as shown in this photograph, the water was so deep that the roadway became impassable and all traffic had to be rerouted. Often businesses and homes were invaded by the muddy waters. (Courtesy of the Maryland Collection, University of Maryland Libraries, Special Collections.)

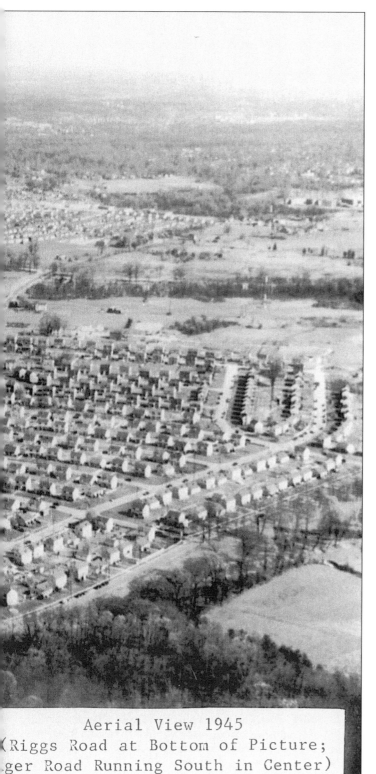

Aerial View 1945
(Riggs Road at Bottom of Picture;
ger Road Running South in Center)

A 1945 aerial view shows Riggs Road at the bottom of the picture with Ager Road running south in the center. The housing development in the foreground is Green Meadows. Note that East-West Highway (Route 410) ended at Riggs Road at the time and later was extended and cut toward the left. (Submitted by Ann H. Thompson of Hyattsville; courtesy of the Green Meadows Citizens Association.)

25

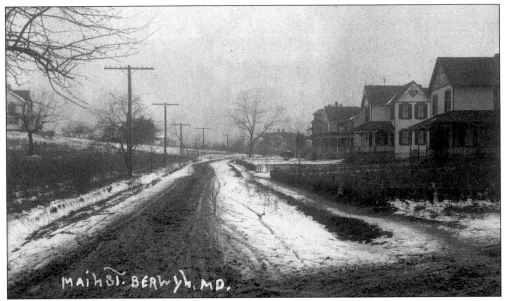

This *c.* 1900 photo shows Main Street in Berwyn, a historic section of College Park. Today, it is Route 1 (Baltimore Avenue) in College Park. (Submitted by the Prince George's County Historical Society.)

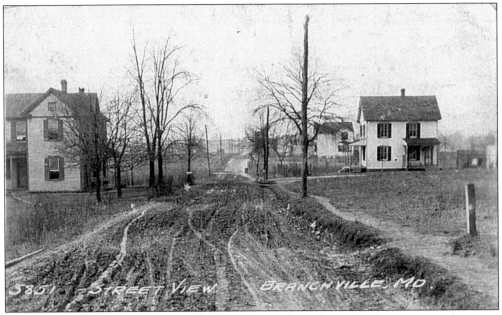

Back on March 4, 1913, when this photograph was taken, this road, like so many others, was just a dirt road. The location of the photograph was 5851 Street View in Branchville, which is one of the older parts of College Park. (Submitted by Susan Reidy, historian for the Natural and Historical Resources Division of Maryland-National Capital Park & Planning Commission.)

Brentwood is the location of this photograph taken June 15, 1937. Workers were starting curbs and gutters by setting forms. (Courtesy of the Works Projects Administration Photo Collection, University of Maryland Libraries, Special Collections.)

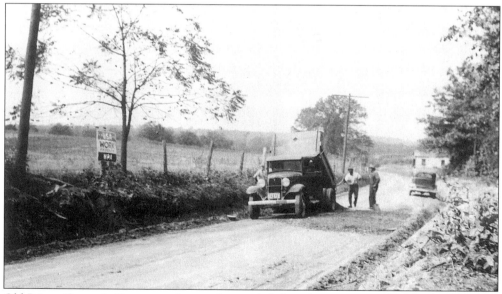

Old Prince George's County roads were dirt roads before they were paved. This photograph of Ardmore Road (Farm to Market) was taken on October 5, 1936. Workers were spreading gravel as the beginning of gravel work. (Courtesy of the Works Projects Administration Photo Collection, University of Maryland Libraries, Special Collections.)

Looking south on Cheverly Avenue, the site of the Magruder Spring is on the left at the base of the large tree in the center. Renamed the Cheverly Spring by Robert Marshall, it has been declared a Prince George's County Historical Site and has reverted back to its earlier designation as the Magruder Spring. According to tradition, this spring was used by the British troops marching toward Washington on August 24, 1814, before the Battle of Bladensburg during the War of 1812. This spring was the water source for the Mount Hope tobacco plantation, and it was the primary source of water for town residents in the early 1920s. The street was paved in 1920. (Submitted by Raymond W. Bellamy Jr., town historian for the Town of Cheverly.)

A very early 1925 view of Cheverly Avenue is shown looking north. On the left is the Stearns House, a Sears-Roebuck Vallonia Model. It is the present home of Katherine Soffer and Mal Hart and was built in 1923 by Robert Marshall, Cheverly's founder. Note the water pipes about to be laid on the far right. Water service was provided to Cheverly in 1925. (Submitted by Raymond W. Bellamy Jr., town historian for the Town of Cheverly.)

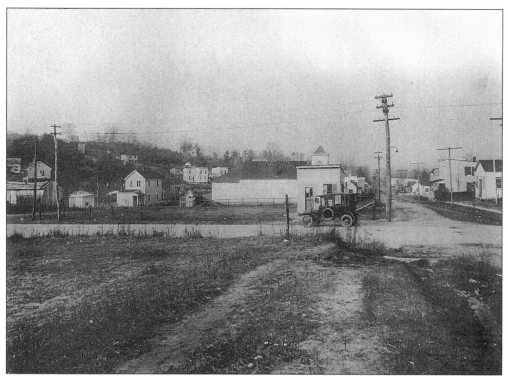

This photograph shows the corner of Sixty-second in Capitol Heights. (Submitted by Susan Reidy, historian for the Natural and Historical Resources Division of Maryland-National Capital Park & Planning Commission.)

Clearing was done for a new location of the Marlboro, Croom Station Road (Farm to Market) next to the location of the old dirt road through the woods. Tree stumps were grubbed in preparation for pulling with a state roads tractor. The photograph was taken on May 5, 1936. (Courtesy of the Works Projects Administration Photo Collection, University of Maryland Libraries, Special Collections.)

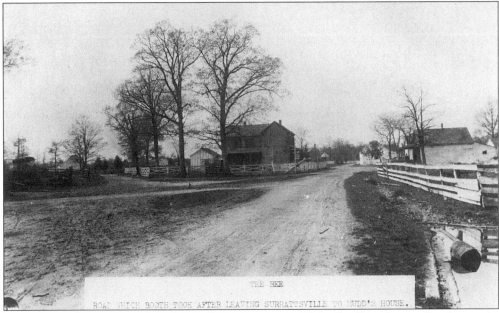

THE BEE
ROAD WHICH BOOTH TOOK AFTER LEAVING SURRATTSVILLE TO MUDD'S HOUSE.

The village of T.B., *c.* 1900, is shown facing west on modern-day Brandywine Road, near its intersection with Dyson Road. The village takes its name from an early land grant holder, Thomas Brooke. He marked the boundaries of his large plantation with fieldstones bearing his initials. The village grew around the northwest boundary marker, which rested where Accokeek Road now crosses Route 5 (Branch Avenue). (Submitted by Joan L. Chaconas, program assistant for the Surratt House Museum.)

This is a view from St. John the Evangelist Roman Catholic Church, looking south along Main Street in Clinton, *c.* 1920s. (Submitted by Joan L. Chaconas, program assistant for the Surratt House Museum.)

New ditch lines are shown being cut by hand into Temple Hill Road (Farm to Market). The photograph, which also shows old cars from that period of time, was taken on August 6, 1936. (Courtesy of the Works Projects Administration Photo Collection, University of Maryland Libraries, Special Collections.)

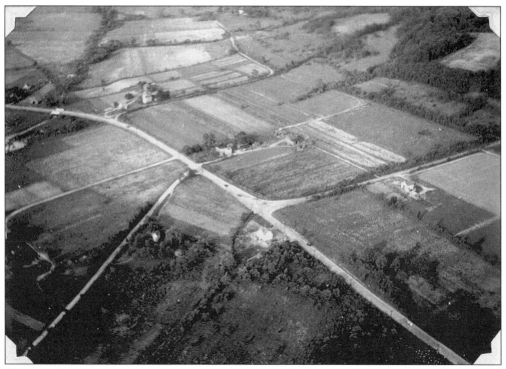

This aerial view shows the intersection of Livingston Road and Old Fort Road in Oxon Hill in 1939. Also seen is the Old County Road leading to Saint John's Church in Broad Creek, currently the only county-designated Historic District. This intersection is now the Livingston Square Shopping Center area. (Submitted by Phyllis A. Luskey Cox of Oxon Hill.)

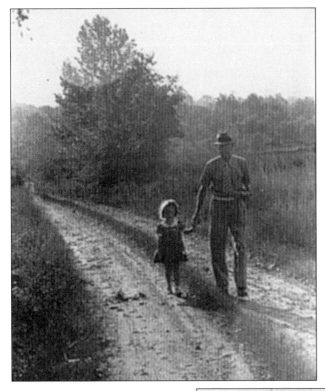

James Richard Cadell (1882–1945) walks down the Old County Road with his granddaughter, Phyllis A. Luskey, in this photograph taken in 1939. The Old County Road went to Saint John's Church in Broad Creek. It was the dividing line between Piscataway Voting District No. 5 and Oxon Hill No. 12. (Submitted by Phyllis A. Luskey Cox of Oxon Hill.)

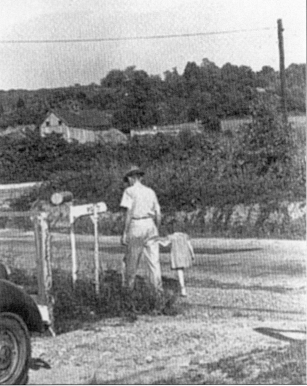

This photograph was taken in 1939 at the Broad Creek intersection of Livingston Road and Old Fort Road in Oxon Hill. John Russell's barn can be seen in the background. The site is now the location of Livingston Square Shopping Center. Walking down the road holding hands are James Richard Cadell (1882–1945) and his granddaughter, Phyllis A. Luskey, who submitted this photograph.

Three
TRANSPORTATION

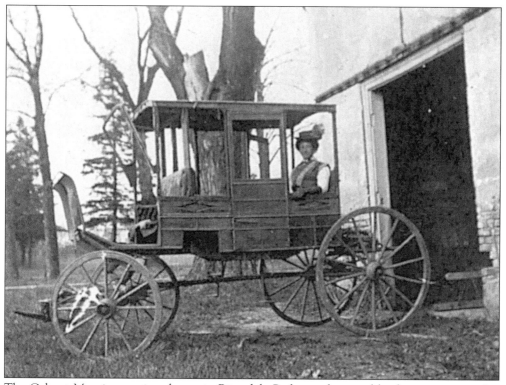

The Calvert Mansion carriage house in Riverdale Park was destroyed by fire some years after the date of this photograph. Mrs. Eva C. Chase is shown in 1912 using this vintage carriage as the setting for a unique scene of yesteryear. (Submitted by Riverdale Park mayor Ann Ferguson from the *Town of Riverdale, Maryland 1920–70*; courtesy of Mrs. Ruth Chase Welsh.)

The old Toonerville Trolley ran along Edmonston Road from Riverdale Park to Washington, D.C. Commuters of today might find it interesting to note that the trolley car run between Riverdale Park and Washington took 39 minutes. In fact, though, it wasn't a trolley to begin with. The first was run on batteries with a stove, shovel, and broom at one end, and it ran from Berwyn Heights to Fifteenth and H Streets in northeast Washington. (Submitted by Riverdale Park mayor Ann Ferguson from the *Town of Riverdale, Maryland 1920–70*.)

A steam engine was photographed pulling into Bowie Railroad Station, c. 1895–1910. Bowie was chartered as "Huntington City" in 1870 and then renamed "Bowie" in honor of Governor Oden Bowie. Some of the railroad buildings were destroyed in 1910 by a fire. (Submitted by Stephen Patrick, curator of the Bowie City Museums.)

A train at Bowie Station is shown as it headed down the Pope's Creek Line of Pennsylvania Railroad to Southern Maryland, c. 1910. The passenger train crew members are, from left to right, "Pokey" Morris, who delivered mail from the train to the post office; Houston Morris, express clerk; Warren Houck, conductor; William H. Thirles, brakeman; Edward A. Lancaster, baggage master; John W. Ryan, mail clerk; Luke Seitz, fireman; and West Charters, engineer. (Submitted by Stephen Patrick, curator of the City of Bowie Museums.)

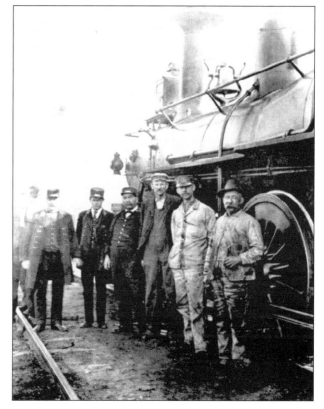

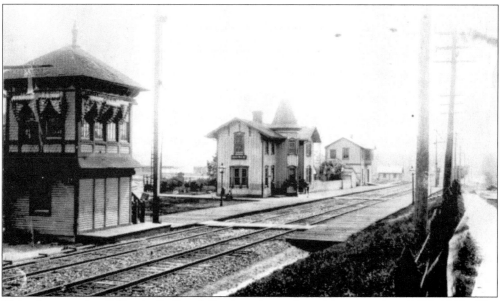

This photograph of Bowie Railroad Station shows how it appeared c. 1895–1910. The Baltimore and Potomac Railroad line ran through Bowie. Now the line is used by Amtrak. (Submitted by Stephen Patrick, curator of the City of Bowie Museums.)

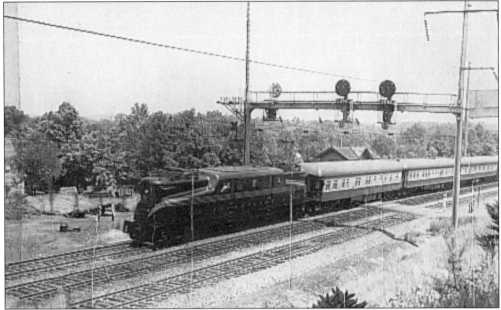

In 1939, the Royal Train for King George VI and Queen Elizabeth was photographed heading for its destination. The Royal Train is traveling along the Pennsylvania Railroad and passing the station in Lanham. (Submitted by the Prince George's County Historical Society.)

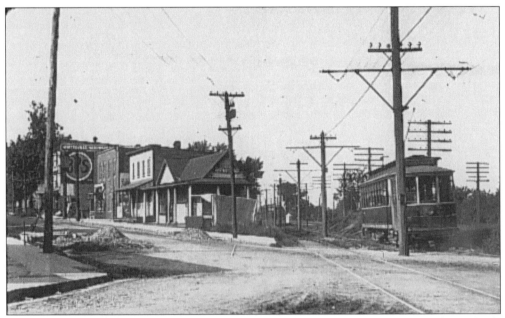

This photo of the Hyattsville Trolley is on the trolley line that looks north on today's Rhode Island Avenue. Rhode Island Avenue took over the right-of-way of the trolley tracks. The road that angles to the left in front of the buildings is today's Baltimore Avenue (Route 1). This photo was taken prior to the construction of the Flatiron Building that is located in the 'V' where Rhode Island and Baltimore Avenues intersect. (Photo by Harvey Davison; contributed by John E. Merriken; submitted by the Prince George's County Historical Society.)

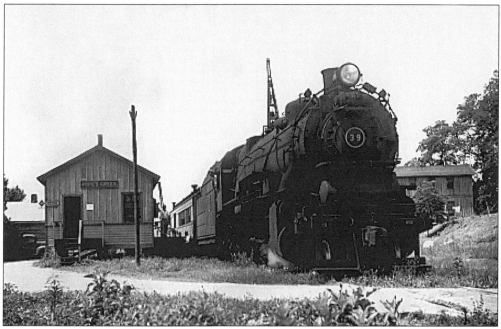

This photo shows the end of the Pope's Creek Line in Upper Marlboro. Pope's Creek was a line of the Pennsylvania Railroad. (Submitted by the Prince George's County Historical Society.)

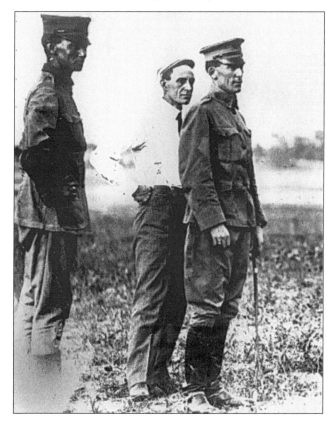

Wilbur Wright (center) is surveying the new College Park Airfield in 1909 with his two students, Lieutenants Frederic Humphreys and Frank Lahm. Their instruction began in September 1909 in the new accepted Wright military aero, the first government plane. Lahm and Humphreys were the first military pilots to fly a government plane. The College Park Airport is the oldest continuously operating airport in the world. (Submitted by Catherine W. Allen, director of the College Park Aviation Museum; courtesy of the National Archives, USAF Collection.)

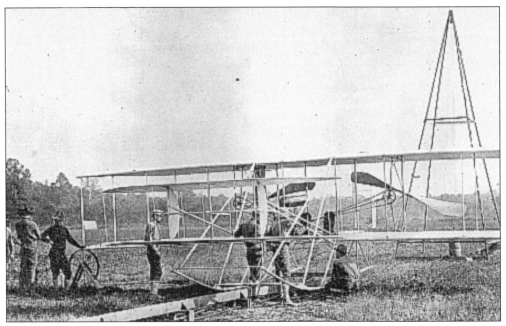

Set up on the launching catapult prior to a flight, the Wright military aero is surrounded by a fleet of dedicated enlisted men assigned to the aeronautical unit based at the College Park Airfield. Notice the wheel on the left, which is one of two that were put under the wings of the aero to wheel it down to the track and back to the hangar. (Submitted by Catherine W. Allen, director of the College Park Aviation Museum; courtesy of the National Archives, USAF Collection.)

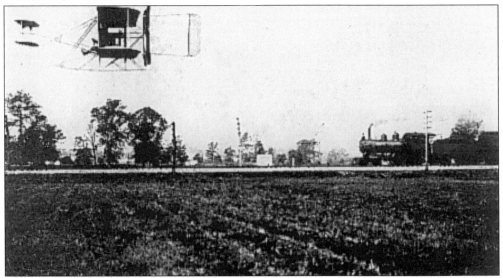

The exploits and training of Lieutenants Humphreys and Lahm at College Park Airfield by Wilbur Wright were closely followed by the media. Three area newspapers posted journalists at the field every day. This photo ran with the caption "The Race Between Two Modes of Transportation— the plane racing the train!" Shown in 1909 is Lt. Frank Lahm racing a Baltimore and Ohio train at the College Park Airfield. (Submitted by Catherine W. Allen, director of the College Park Aviation Museum.)

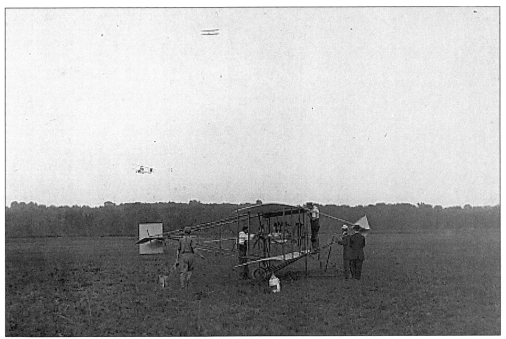

The Army Aviation School at College Park Airfield instructed military officers in Wright, Curtis, and Burgess-Wright aircraft. Here are some enlisted men and mechanics from the school gassing up the Curtiss. The Curtiss was a single seat aero, *c.* 1911. (Submitted by Catherine W. Allen, director of the College Park Aviation Museum, S. Bowdoin Collection.)

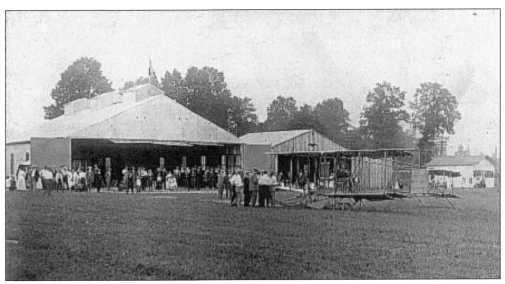

A view of the Rex Smith Aeroplane Co. hangars can be seen in this photograph. The 1911 Rex Smith aero is ready for a flight before a crowd of spectators. You can still see some of the foundation of the 1910 Rex Smith hangar at the College Park Airfield, the oldest continuously operating airport in the world. (Submitted by Catherine W. Allen, director of the College Park Aviation Museum, S. Bowdoin Collection.)

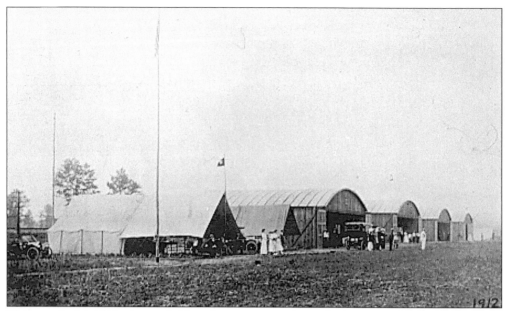

This wonderful 1911 picture (although someone early on had written 1912) of the Army Aviation School at College Park showed the first four early hangars on the field. The medical tent with some of its personnel is in the foreground, with the mess tent behind it. (Submitted by Catherine W. Allen, director of the College Park Aviation Museum; courtesy of the National Archives, USAF Collection.)

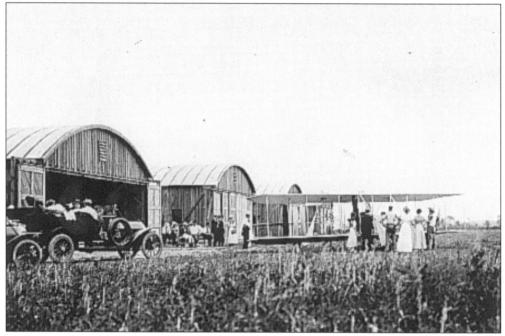

Visitors to the Army Aviation School at College Park Airport in 1911 and 1912 were numerous, since flying and flying machines were still new to many. Here, visitors flock around a Wright B outside four of the school's hangars. (Submitted by Catherine W. Allen, director of the College Park Aviation Museum, B. Strobell Collection.)

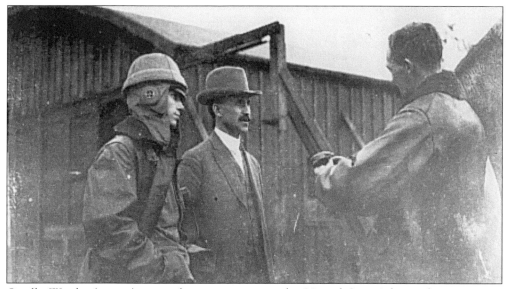

Orville Wright (center) was a frequent visitor to the United States' first military aviation school throughout 1911 and 1912. He is shown here talking to Lieutenants Thomas Milling (left) and Henry "Hap" Arnold (right), two of the school's Wright instructors. Orville was always interested in listening to the opinions and thoughts of the school's military pilots, *c.* 1911. While he was there that year, he lived in a still-existing house owned by Alan Tyler on Bowdoin Avenue in College Park. (Submitted by Catherine W. Allen, director of the College Park Aviation Museum, B. Strobell Collection.)

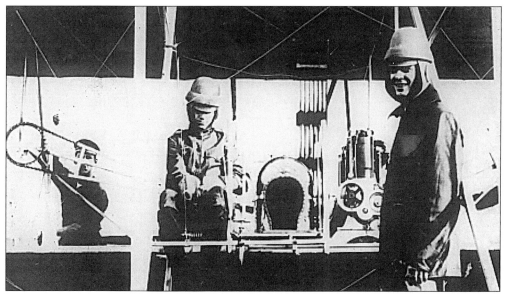

Lieutenants Tommy Milling (left) and "Hap" Arnold (right) at College Park Airfield were photographed with a Wright B. These two popular aviators were often in the newspaper since there were three journalists assigned to the Army Aviation School throughout 1911 and 1912. Notice the early style of helmets that were used in 1911 at the College Park Airfield. (Submitted by Catherine W. Allen, director of the College Park Aviation Museum; courtesy of the National Archives, USAF Collection.)

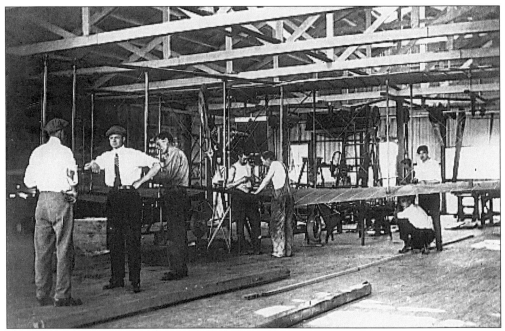

This photograph was taken inside the Rex Smith Aeroplane Co. at the College Park Airfield in 1912. Rex Smith (with his back to us) is talking to aviator Paul Peck. Peck went on to become a well-known exhibition pilot. (Submitted by Catherine W. Allen, director of the College Park Aviation Museum.)

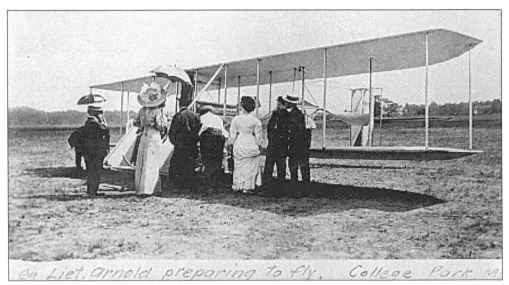

Lieutenant "Hap" Arnold, hidden from view, is shown preparing to fly a Wright B in this photograph taken at the College Park Airfield in 1912. He was the focus of much attention, both in the media and from visitors to the Army Aviation School at College Park, as there were three journalists assigned to the Army Aviation School throughout 1911 and 1912. Arnold, one of the school's first officer instructors, later became the Air Force's first five-star general. (Submitted by Catherine W. Allen, director of the College Park Aviation Museum; courtesy of the National Archives, USAF Collection.)

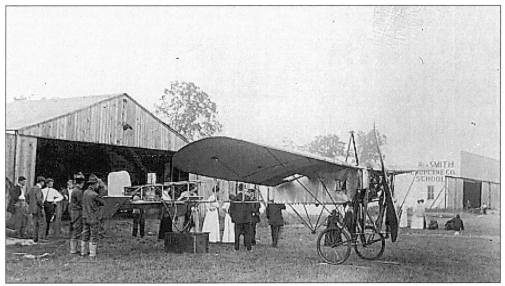

The National Aviation Company was formed to give instruction on and sell Wright, Curtiss, and Bleriot aircraft. Shown here is a 1912 Bleriot ready for a flight at College Park Airfield, the oldest continuously operated airport in the world. (Submitted by Catherine W. Allen, director of the College Park Aviation Museum.)

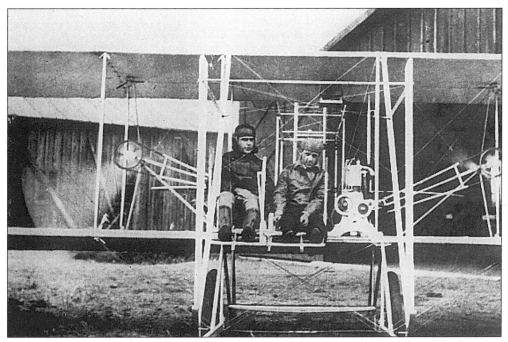

Arthur Welsh (right) was one of the Wright brothers' favorite test pilots. Each time a plane was accepted by the Army Aviation School in College Park, it had to undergo tests prior to acceptance. Welsh was killed with Lieutenant Hazelhurst (left) while testing the new Wright C model in June 1912. (Submitted by Catherine W. Allen, director of the College Park Aviation Museum; courtesy of the National Archives, USAF Collection.)

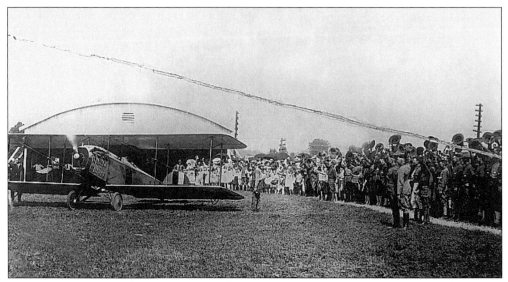

On August 12, 1918, the first U.S. Postal Air Mail service was inaugurated at College Park Airfield after a three-month trial by the Army. Shown here is a standard aircraft with pilot Max Miller taking off in front of a crowd. (Submitted by Catherine W. Allen, director of the College Park Aviation Museum; courtesy of the NASM, Smithsonian Institution.)

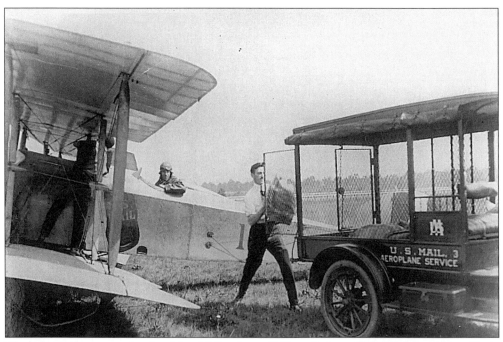

The Air Mail route took pilot Max Miller from College Park to Philadelphia to New York. Shown here is Max in his standard bi-plane refueling and dropping off the mail at Hazelhurst Field in New York. Incidentally, Hazelhurst Field was named in honor of Lieutenant Leighton Hazelhurst, who died in a crash at College Park's Army Aviation School in June 1912. (Submitted by Catherine W. Allen, director of the College Park Aviation Museum; courtesy of the NASM, Smithsonian Institution.)

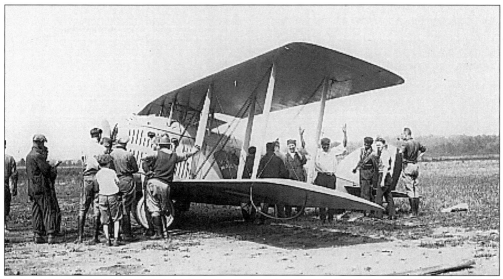

The crew of the U.S. Postal Air Mail service based at the College Park Airfield in 1918 was photographed during one of the early inaugural flights of the mail. Shown is the standard aircraft that made the first flight on August 12, 1918. The original cost was 74¢ per mile, but was changed to 16¢ because of a misprint on the postage. (Submitted by Catherine W. Allen, director of the College Park Aviation Museum, E. Ilch Collection.)

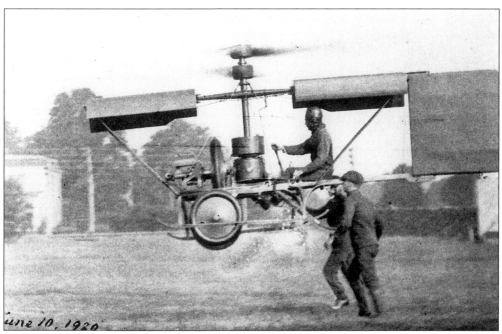

In 1919–1920, Emile Berliner, with his son Henry, brought his experiments with vertical flight to College Park Airfield. They occupied one of the old Army Aviation School hangars. Their 1920 model helicopter had little more than a chassis, an engine, a set of rotors, and a rudder. Shown here is a helicopter being piloted by Henry Berliner. (Submitted by Catherine W. Allen, director of the College Park Aviation Museum; courtesy of NASM, Smithsonian Institution.)

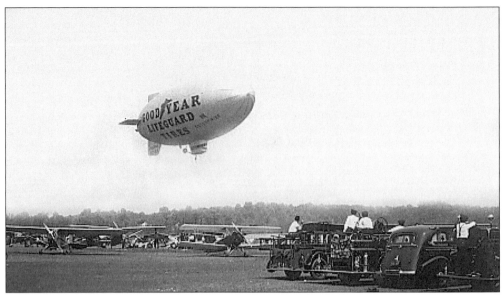

During the 1930s and 1940s, George Brinckerhoff operated and managed the College Park Airfield, now the oldest continuously operated airport in the world. He also sponsored many sensational airshows. The Goodyear Blimp was often at the field and was a highlight of this show in the late 1930s. (Submitted by Catherine W. Allen, director of the College Park Aviation Museum, McGovern Collection.)

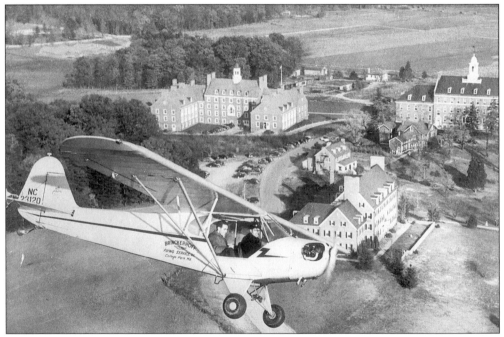

The Brinckerhoff Flying Service utilized primarily Cubs, Fleets, and Wacos for training and flights. Shown here is a Cub over the University of Maryland in College Park. George Brinckerhoff piloted the plane with one of his students, c. 1950. (Submitted by the Prince George's Historical Society; information obtained from Catherine W. Allen, director of the College Park Aviation Museum.)

Four
HISTORIC SITES

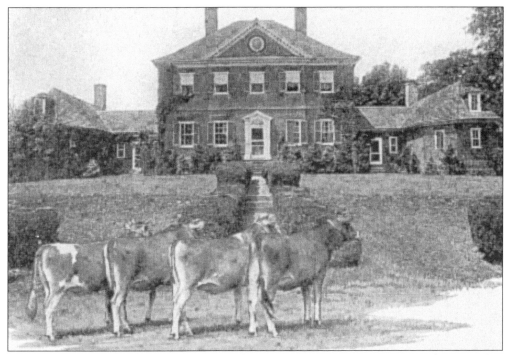

Cows are shown grazing in front of Montpelier Manor Farms, *c.* 1922, in Laurel. Montpelier Mansion is a National Historic Landmark. This photograph was taken from a 1922 auction catalog. Montpelier was built for Major Thomas Snowden and, in the twentieth century, was the home of assistant secretary of state Breckinridge Long. (Submitted by Friends of Montpelier.)

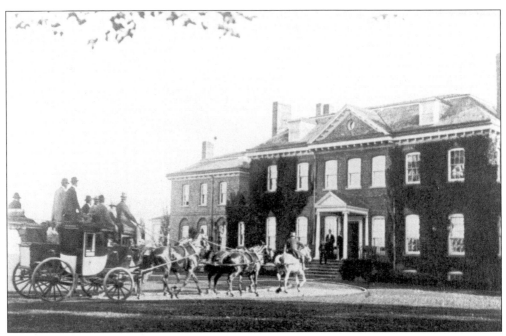

A coach and horses were photographed pulling up to Belair Mansion in 1916. In an attempt to demonstrate the stamina and usefulness of thoroughbred horses, William Woodward Sr., the owner of Belair Mansion in Bowie, organized a journey by coach from New York to Bowie. The 250-mile trip took four days and 64 horses. The mansion was built in the 1740s for Samuel Ogle, the provincial governor of Maryland, and was the country home of his son Benjamin Ogle, state governor from 1798 to 1801. (Submitted by Stephen Patrick, curator of the City of Bowie Museums.)

Mount Calvert in Croom was built in the late 1700s by John Brown and remained in the family until 1835 when it was sold to Captain John Brookes. Mount Calvert is the only historic structure remaining at the site of Charles Town, the first seat of the Prince George's County government. More modest in scale than the county's other Federal-style mansions, it is an outstanding example of the type, distinguished also by its scenic location overlooking the confluence of the Western Branch and the Patuxent River. (Courtesy of the University of Maryland Libraries, Special Collections.)

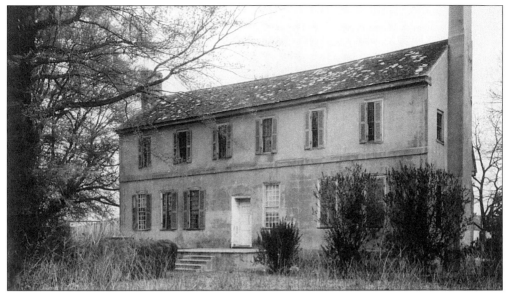

Melwood Park in the Upper Marlboro vicinity was built *c.* 1750 by Ignatius Digges and raised to its present irregular two stories by his widow *c.* 1800. This unique dwelling was visited by George Washington on several occasions. The British Army camped near here during their march on Washington in August 1814. (Courtesy of the University of Maryland Libraries, Special Collections; information obtained from the *Illustrated Inventory of Historic Sites in Prince George's County* by Maryland-National Capital Park & Planning Commission.)

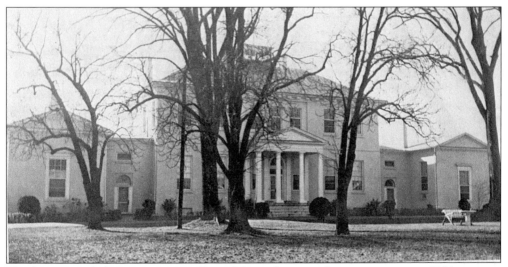

This historic and elegant mansion in Riverdale, at the time of its construction in 1801, was one of the finest examples of Georgian architecture in existence. Modeled after the Chateau du Mick, the home of Baron de Stier in Belgium, the house was made of brick, stuccoed, and painted. The mansion was home to a branch of the Calvert family for much of the nineteenth century. (Submitted by Riverdale Park mayor Ann Ferguson from the *Town of Riverdale, Maryland 1920–70*; courtesy of James C. Wilfong Jr.)

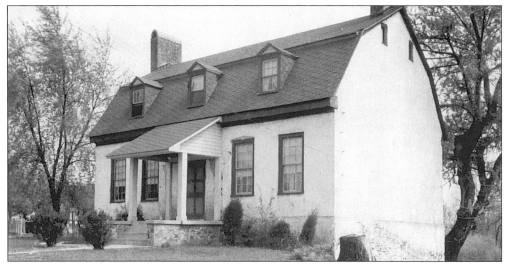

The Magruder House, also called "The Old Stone House" or "The William Hilleary House," is on the National Register of Historic Places and the nationwide Historic American Buildings Survey. William Hilleary built the house c. 1746 and sold it to Richard Henderson. George Washington dined there on May 9, 1787. In August 1814, invading British troops passed the house on their way to the Battle of Bladensburg. Unverified tradition maintains that the only American civilian resistance offered at Bladensburg came from that house. After battle that day, the house was used as a hospital for wounded troops. Prince George's Heritage received it in 1979, and the restoration of the property occurred in 1982. (Courtesy of the University of Maryland Libraries, Special Collections.)

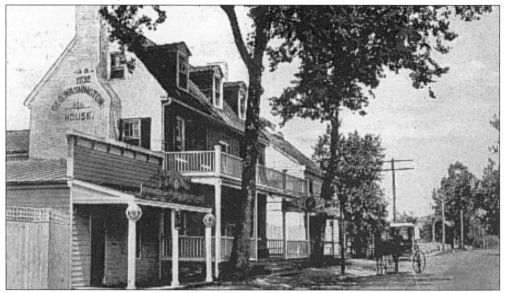

The George Washington House in Bladensburg was built c. 1760. It was built originally as a store, part of a commercial complex that included a tavern and a blacksmith shop. From the mid-nineteenth to the mid-twentieth century, it served as a tavern. Presently, it houses offices. (Submitted by the Prince George's County Historical Society; information obtained from the *Illustrated Inventory of Historic Sites in Prince George's County* by Maryland-National Capital Park & Planning Commission.)

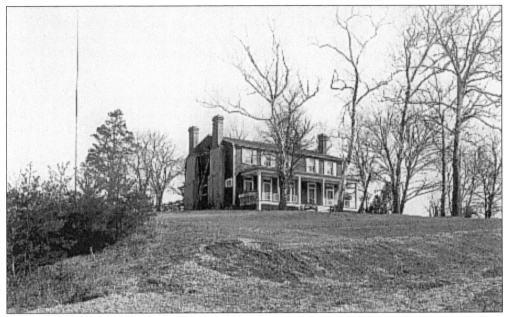

This view of Mount Hope, One Cheverly Circle, was taken in 1926. This 12-room antebellum home was built by Fielder Magruder in 1838 to 1839 on the foundations of a late eighteenth-century overseer's house. The home was modified in 1919 by Robert Marshall, the founder of Cheverly, who lived there from 1919 to 1929, and he renamed it Crestlawn. From 1941 to 1977, it was owned by Fred Gast, the first mayor of Cheverly. Currently, Dale Manty owns the house, which appears on the town seal. (Submitted by Raymond W. Bellamy Jr., town historian for the Town of Cheverly.)

The Bellamy House at 2819 Cheverly Avenue, known as Belmar in 1926, was the 22nd home built in Cheverly. This is a Sears-Roebuck Alhambra Model and was built by Robert Marshall, Cheverly's founder, in 1925. In 1927, the house was purchased by Raymond Bellamy Sr. (Submitted by Raymond W. Bellamy Jr., town historian for the Town of Cheverly, who presently resides there with his wife, Betty.)

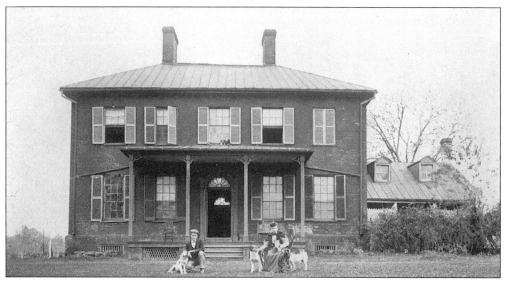

This c. 1898 photo shows the original wing of Mount Lubentia in Largo. On the lawn is Washington Beall Bowie and his mother, Rosalie Beall Bowie. A unique eighteenth-century octagonal dairy, moved from a related plantation (Graden, now destroyed), stands on the grounds, as well as several farm outbuildings. (Submitted by the Prince George's County Historical Society; information obtained from the *Illustrated Inventory of Historic Sites in Prince George's County* by Maryland-National Capital Park & Planning Commission.)

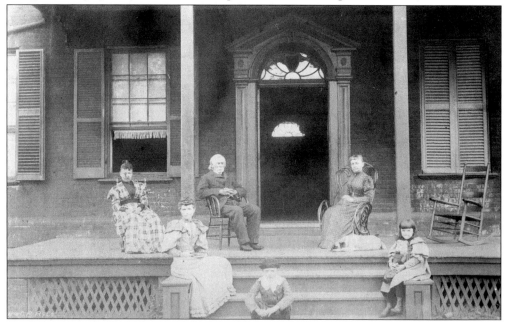

Washington J. Beall and his daughters are sitting on the porch of Mount Lubentia in Largo. This photograph is c. 1890. Mount Lubentia was built by Dennis Magruder of Harmony Hall in 1798, probably incorporating an earlier structure. Mount Lubentia is an example of Federal-style mansion architecture. (Submitted by the Prince George's County Historical Society; information obtained from the *Illustrated Inventory of Historic Sites in Prince George's County* by Maryland-National Capital Park & Planning Commission.)

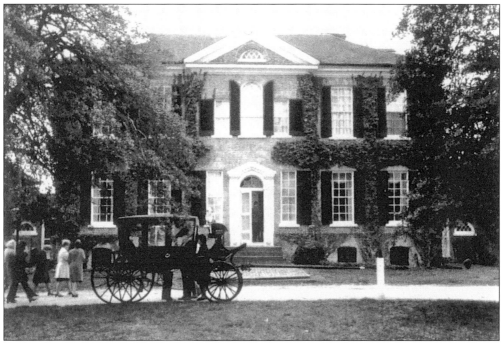

Built in 1784–1786, His Lordship's Kindness (also known as Poplar Hill), a National Historic Landmark, has been home to several families, including the Darnalls, who built it, and the last owners—the Walton family. The Walton family owned the carriage in front. (Submitted by Friends of Montpelier; courtesy of The John M. and Sara R. Walton Foundation.)

His Lordship's Kindness, an elegant five-part Georgian mansion, includes a private Catholic chapel in one wing. A smokehouse, wash house, and aviary are among the outstanding buildings, and there is a family graveyard on the grounds. Surrounded partially by an operating horse farm, it is a superb example of an elegant and carefully detailed plantation house. (Submitted by Friends of Montpelier; courtesy of The John M. and Sara R. Walton Foundation; information obtained from the *Illustrated Inventory of Historic Sites in Prince George's County* by Maryland-National Capital Park & Planning Commission.)

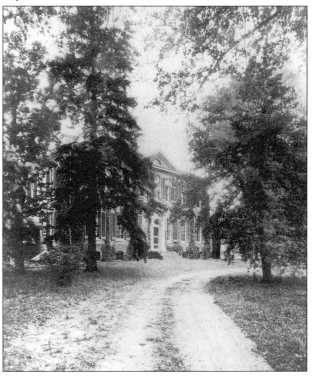

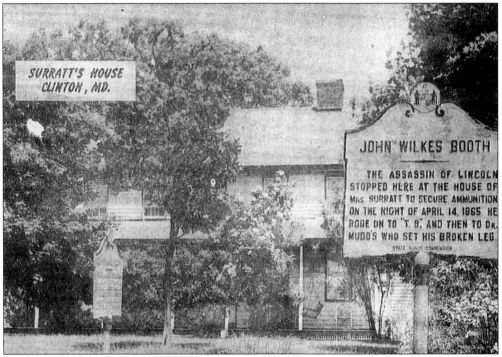

This is a c. 1940s postcard of the Surratt House in Clinton. The Surratt House Museum, which is now located in the building, maintains a large photographic archive that is used frequently by researchers and film crews working in the Lincoln/Surratt/Civil War field. (Submitted by Joan L. Chaconas, program assistant for the Surratt House Museum.)

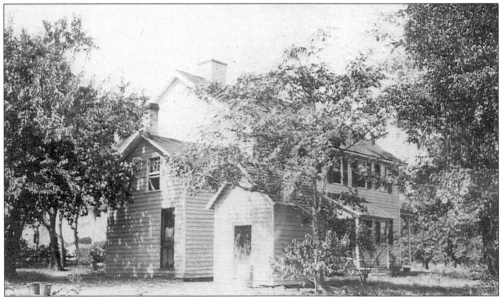

This September 19, 1915 photograph was taken of the rear view of the Surratt House in Clinton, which was owned at that time by a Mr. Wheatley. In the front is the meat house. Dora is standing at the kitchen door. (Submitted by Joan L. Chaconas, program assistant for the Surratt House Museum.)

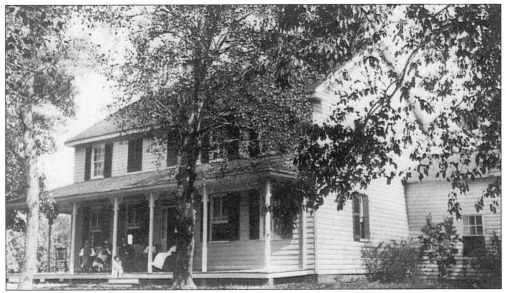

A September 19, 1915 photograph was taken of Penn Grove Farm in Clinton. (Submitted by Joan L. Chaconas, program assistant for the Surratt House Museum.)

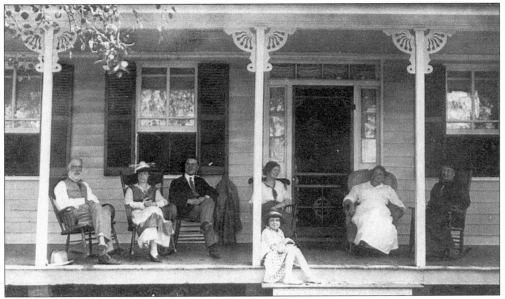

This photograph of the Surratt House in Clinton was taken September 19, 1915, when it was known as Penn Grove Farm. From left to right are Mr. Wheatley, Miss Hazel Beck, Mr. H.A. Beck, Miss Wheatley, Miss Dorothy Beck, Mrs. Wheatley, and Mrs. Byers. (Submitted by Joan L. Chaconas, program assistant for the Surratt House Museum.)

A group of tourists accompanied the "Pathfinder" editor of the *Washington Star* in 1912 to find the Surratt House in Clinton via an open-top motor coach. If you look closely at the right edge of the photograph, you can see the back edge of the top of the motor coach. (Submitted by Joan L. Chaconas, program assistant for the Surratt House Museum.)

Piscataway Tavern is shown as it appeared *c.* 1870. The original structure, built in the mid-1700s, is to the left. Around 1810, the larger side-gabled structure was added by the Clagett family, who continued to operate it as a tavern and store. During the Civil War, the tavern was a hotbed of Southern sympathies. Thomas Harbin, a cagey Confederate spy, ran the tavern at the beginning of the war. (Submitted by Joan L. Chaconas, program assistant for Surratt House Museum.)

Five

HOUSES AND PLACES

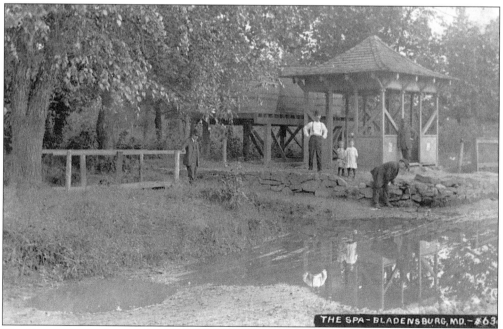

The Spa was located in northern Bladensburg beside where the Northeast Branch flows into the Anacostia River. Today, it would be east of Route 1 and near Tanglewood Drive. (Submitted by the Prince George's County Historical Society.)

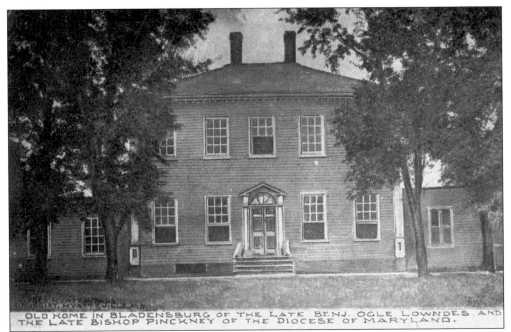

OLD HOME IN BLADENSBURG OF THE LATE BENJ. OGLE LOWNDES, AND THE LATE BISHOP PINCKNEY OF THE DIOCESE OF MARYLAND.

Blenheim was on top of a hill in Bladensburg and was the residence of Benjamin Ogle Lowndes. His sister, Elizabeth, married Bishop Pinkney of the Diocese of Maryland, who also resided at Blenheim. Today, the Hilltop Apartments, up from the Eastern Branch of the Anacostia River, on Route 450, is located on this site. A druggist in Hyattsville created this drawing of the old home. (Submitted by the Prince George's County Historical Society.)

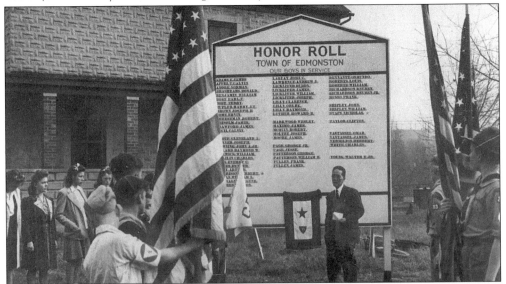

A dedication ceremony of an honor roll was conducted for the local men in service during World War II. The ceremony took place in Edmonston on November 21, 1943. Mayor Kinjiro Matsudaira, center, was from a royal family of Japan and was appointed mayor of Edmonston in 1943 during World War II. He was elected mayor in 1927 and served for several years as both mayor and town council member. (Submitted by B. Adele Compton, clerk-treasurer for the Town of Edmonston.)

The Ella Calvert Campbell house was located in College Park at the corner of College Avenue and Columbia Avenue, but it was torn down in the early 1960s. Ella received the property in what is now Old Town College Park as her share of land from her father, Charles Calvert of Riversdale. Ella married Duncan Campbell, the son of John A. Campbell, associate justice of the Supreme Court and secretary of war for the Confederacy. John Oliver Johnson purchased the house and land from Ella Campbell and used it to found College Park in 1890. Johnson, great grandfather of Katharine D. Bryant, lived in the house until his death when it became a fraternity house. (Submitted by the Prince George's County Historical Society.)

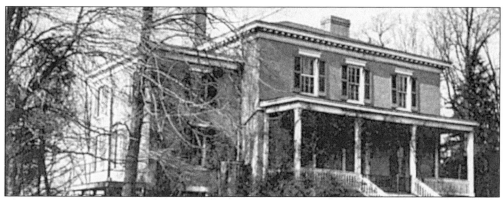

Charles Baltimore Calvert built McAlpine on his portion of the Riversdale property along Route 1 at the College Park border around 1860. The original cement gate posts, engraved with the words "Calvert" and "McAlpine" were discovered lying on their sides, broken from their foundations, and have been placed upright. In World War II, temporary housing, adjacent to the ERCO plant that made Ercoupe airplanes and war materials, was built on the McAlpine site. Due to layoffs after the war, the Calvert Homes Project at McAlpine was demolished in the 1950s. Nothing was salvageable. Several unsuccessful attempts were made to restore the mansion as a historical site. (Submitted by Riverdale Park mayor Ann Ferguson from the *Town of Riverdale, Maryland 1920–70*.)

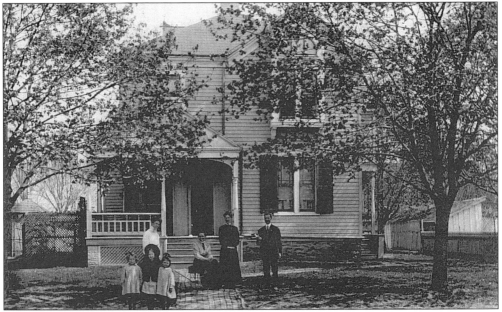

This photograph is of the Cronmiller House and family on Washington Boulevard in Laurel. It was taken in 1908. (Submitted by Kate Arbogast, Laurel Museum director, and Elizabeth Compton of the Laurel Museum and Historical Society.)

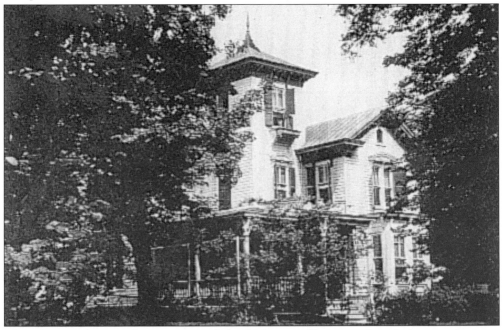

This photograph was taken in 1919 of the Halverson House on Laurel Avenue, between Washington Boulevard and Second Street in Laurel. The ledger of the Halverson Boarding House in the Laurel Museum has entries showing Major and Mrs. Dwight Eisenhower dining there and having tea with friends during the years when (later) U.S. President Eisenhower was stationed at nearby Fort George Gordon Meade. (Submitted by Kate Arbogast, Laurel Museum director, and Elizabeth Compton of the Laurel Museum and Historical Society.)

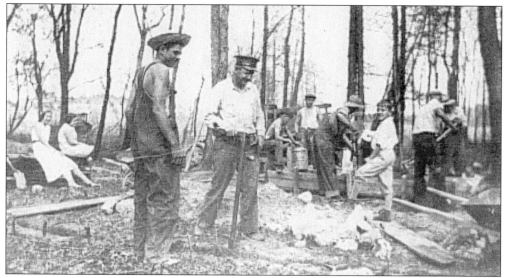

The Bowie-Vansville Association is shown clearing land and building its clubhouse in 1932. The location, in what is now the Beltsville Agricultural Research Center, was donated by Lena Knauer, "The Mother of the Community," in 1929. The clubhouse is still in use today as a community meeting place, even though the community is now spread over a larger geographical area. (Submitted by Barbara Knauer Benfield of Landover Hills, great niece of Lena Knauer.)

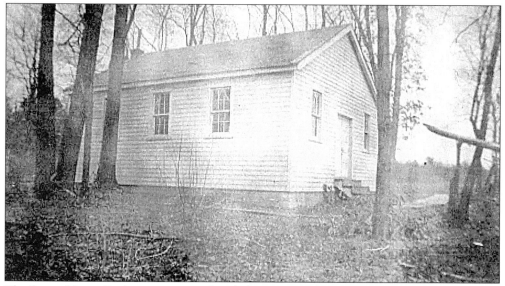

The Bowie-Vansville Association was founded in 1921 to disseminate knowledge about things such as food conservation and productive living. One of the group's objectives was "to discuss the economic problems confronting the members with regards both to production and to marketing, and to make country life less monotonous, less irksome, better rewarded, and more attractive." Members still come to meetings from as far away as southern Prince George's County, Columbia, and Gambrills. (Submitted by Barbara Knauer Benfield of Landover Hills.)

The Jeannette and Mack Brown house is listed in the historical survey of North Brentwood. The house was originally located at 312 School Street, which has been renumbered and renamed to the current 3907 Wallace Road. (Submitted by North Brentwood mayor Lillian K. Beverly.)

A copy of a brochure advertises the homes in Green Meadows built in 1941. Corresponding bungalows were priced at $3,780 with a cash payment of $380 and monthly payments of $26.95. The 18-acre park ran along Sligo Creek, the western edge of the housing development. (Submitted by Ann H. Thompson of Hyattsville; courtesy of the Green Meadows Citizens Association.)

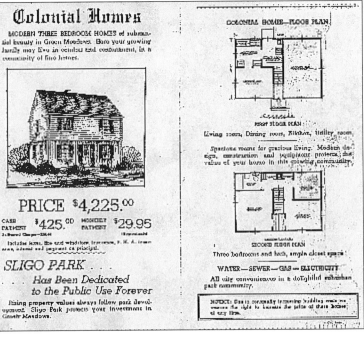

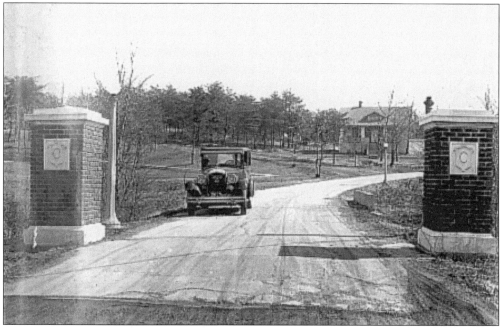

This 1926 photograph depicts the southern entrance to Cheverly and the Haldeman House at 2301 Belleview Avenue. The house was built between December 1921 and February 1922. This was the fourth house built in Cheverly by Robert Marshall, Cheverly's founder. Note that this view looks to the east and is on the portion of Arbor Street that becomes Tuxedo Road. The automobile belonged to Robert Marshall. (Submitted by Raymond W. Bellamy Jr., town historian for the Town of Cheverly.)

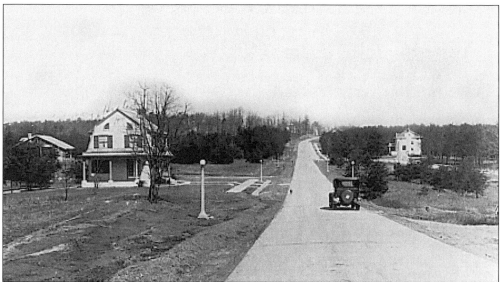

Looking north along Cheverly Avenue in 1926 from south of Forest Road, one can see on the far left the Stearns House at 2807 Belleview Avenue. Just to the right is the Histead House at 2720 Cheverly Avenue, a McClure catalog house. To the far right is the Bellamy House at 2819 Cheverly Avenue. All three houses were built by Robert Marshall, Cheverly's founder. (Submitted by Raymond W. Bellamy Jr., town historian for the Town of Cheverly.)

Beaver Dam Country Club was built in Landover Hills in 1926. The clubhouse was actually converted from a former dairy barn. The structure on the right was part of the farm. The dairy barn had been part of Mount Hope Plantation, which was in Cheverly and was owned by Fielder Magruder (1814–1888). The golf course at Beaver Dam Country Club was designed by Donald Ross, who designed Pinehurst 2 in North Carolina, the site of the 1999 U.S. Open. (Submitted by Raymond W. Bellamy Jr., town historian for the Town of Cheverly.)

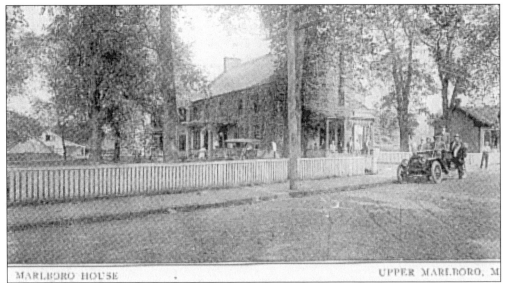

MARLBORO HOUSE UPPER MARLBORO, M

Marlborough House in Upper Marlboro was located on Main Street, which is the street on which you see the car. The Marlborough House stood immediately to the west of the present Upper Marlboro library, formerly the post office. This picture was taken c. 1911. (Submitted by the Prince George's County Historical Society.)

64

This was the home of Frank Peacock located on Ferndale Farm c. 1920. He made and sold baskets. (Submitted by Mary R. Conner of Accokeek.)

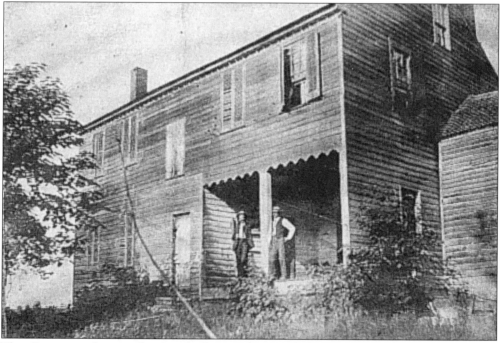

This Riverview home, photographed around 1900, belonged to Ernest Benoit Simpson (1853–1911), seen on the right side of the front porch. Ernest Simpson was the superintendent of Riverview Farm in Fort Washington. He was the stepfather of Mary A. McKay Cadell and the grandfather of Phyllis A. Luskey Cox of Oxon Hill, who submitted the photograph. The house was the birthplace of Agnes Bertha "Bertie" Cadell in 1909 and Mary Belle Cadell in 1910, the mother and aunt of Phyllis A. Luskey Cox. The Cadell family did not reside in the house until after Ernest Simpson's death in 1911.

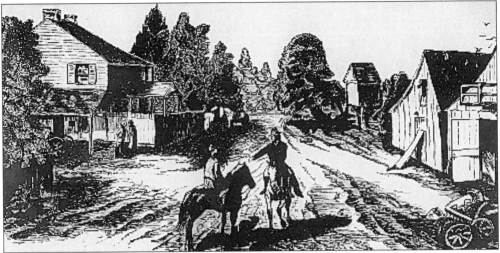

An artist's rendition of the village of Surrattsville was printed in an 1867 issue of *Harper's Weekly* during the trial of John Surratt Jr. (Submitted by Joan L. Chaconas, program assistant for the Surratt House Museum.)

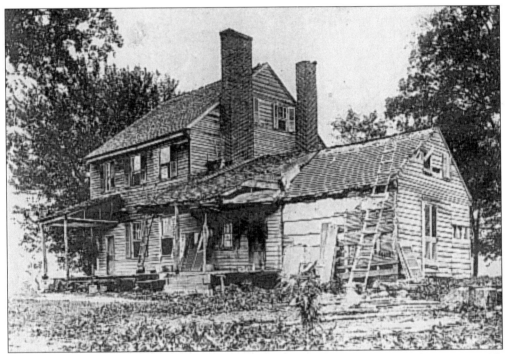

This photograph of Mount Auburn, the home of Captain B.F. Gwynn, was taken on May 25, 1908. The house stood on the southwest corner of modern-day Route 5 (Branch Avenue) and Surratts Road. The plantation was raided by Union troops during the war due to Captain Gwynn's underground Confederate activities. (Submitted by Joan L. Chaconas, program assistant for the Surratt House Museum.)

Six

CHURCHES

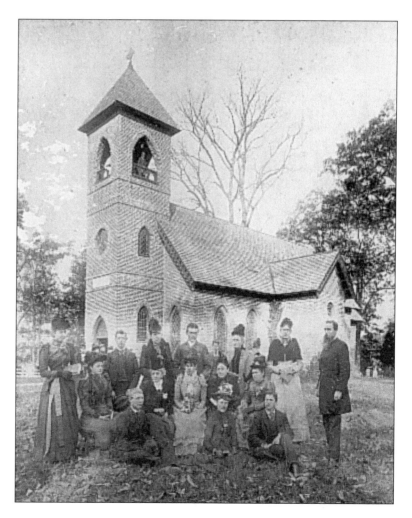

The choir of St. Thomas Episcopal Church in Croom was photographed in the late nineteenth century. The Reverend C.J. Curtis stands at the right. Note the sexton watching from the bell tower. (Submitted by Franklin A. Robinson Jr. of Benedict; courtesy of St. Thomas' Parish Archives.)

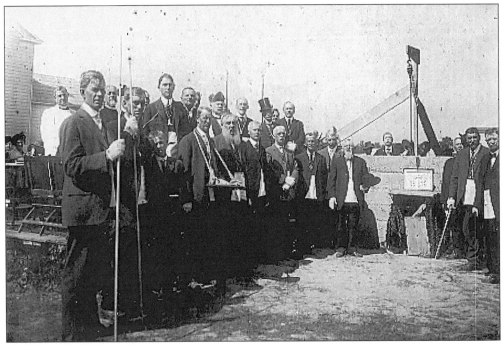

The laying of the cornerstone of the Chapel of the Incarnation was photographed in Brandywine in 1916. Bishop Harding of the Episcopal Diocese of Washington officiated. The Chapel is part of St. Thomas' Episcopal Parks and a Prince George's County Historic Landmark. (Submitted by Franklin A. Robinson Jr. of Benedict; courtesy of St. Thomas' Parish Archives.)

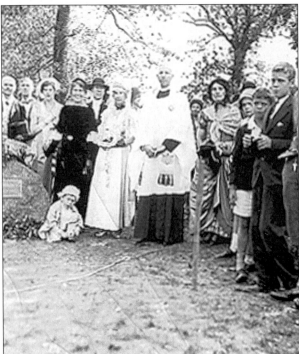

A 1932 celebration at St. Thomas' Church in Croom marked the 200th anniversary of the Act of Assembly authorizing construction of a chapel for St. Paul's Episcopal Parish in 1732. Known as Page's Chapel until 1850, this building later became St. Thomas' Parish Church. (Submitted by Franklin A. Robinson Jr. of Benedict; courtesy of St. Thomas' Parish Archives.)

The stone and brass plaque placed in 1932 marked the 200th anniversary of the Act of Assembly authorizing construction of a chapel for St. Paul's Episcopal Parish in 1732. Known as Page's Chapel until 1850, this building later became St. Thomas' Parish Church in Croom. (Submitted by Franklin A. Robinson Jr. of Benedict; courtesy of St. Thomas' Parish Archives.)

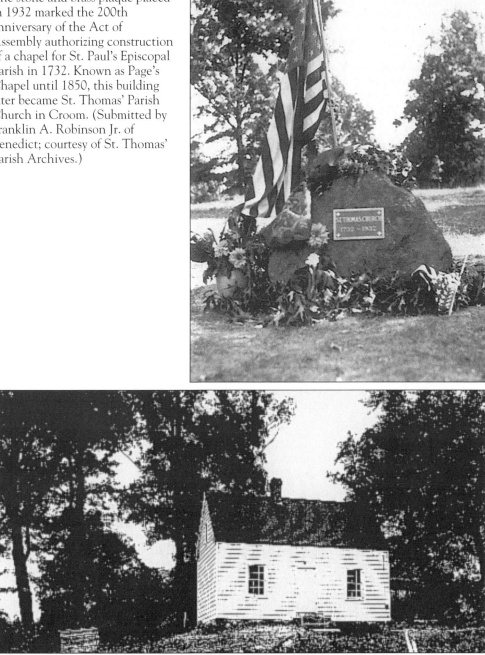

This is the first building used as Ager Road Methodist Church. The building was donated by Mr. Sidney Lust, the owner of a chain of local movie theaters, in 1942. It was located on the corner of Riggs and Ager Roads. By 1946, the building was used as a neighborhood cooperative kindergarten. The building had no toilet, so a portable potty was used. There was an old stove that the fathers of the kindergartners took turns going down early in the morning to light so the place would be warm when the children arrived. (Submitted by Ann H. Thompson of Hyattsville; courtesy of the Green Meadows Citizens Association.)

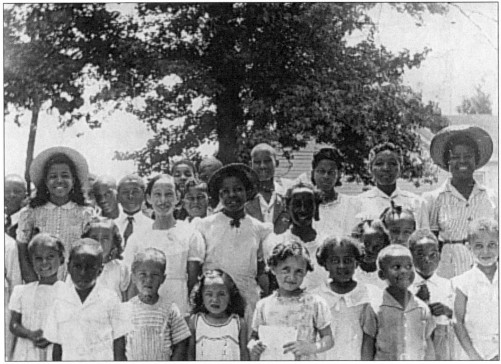

This photograph of the Sunday school class of First Baptist Church in North Brentwood was taken in 1942. Mayor Lillian K. Beverly, who submitted the photograph, is in the last row, third from the right. The Reverend James Jasper and 19 people held the organizational meeting that established the First Baptist Church in 1905 in the home of Mr. and Mrs. James Holmes. Initially, early church services were held outside on the lot where the church would be built and later in the homes of church members. The first church building, completed in 1907, was destroyed by fire four years later. (Information obtained from *Footsteps From North Brentwood: From Reconstruction to the Post World War II Years* by Dr. Frank H. Wilson.)

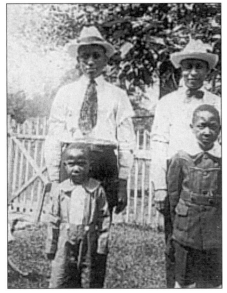

Hammond, Jerome, Harry, and Paige, the sons of the Reverend William H. Thomas, are ready for church, waiting in the front yard. (Submitted by North Brentwood mayor Lillian K. Beverly.)

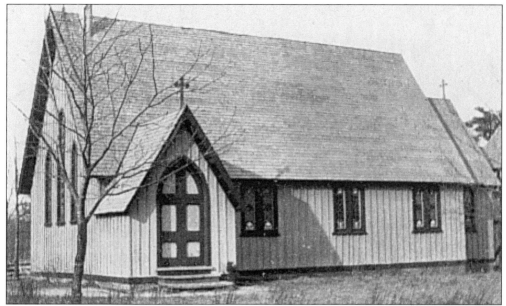

The Church of the Atonement in Cheltenham, part of St. Thomas' Episcopal Parish, was photographed in the early twentieth century. The church was constructed in 1874, but it was declared redundant and demolished in the 1940s. (Submitted by Franklin A. Robinson Jr. of Benedict; courtesy of St. Thomas' Parish Archives.)

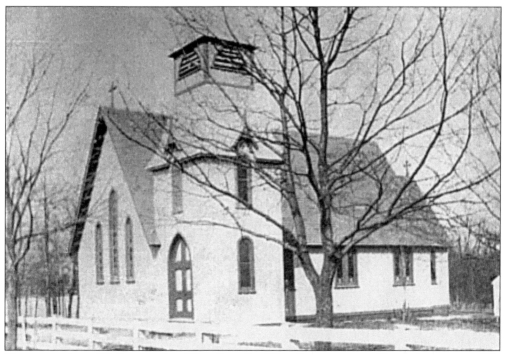

Here is another old photograph of the Church of the Atonement in Cheltenham, part of St. Thomas' Episcopal Parish. In this photograph, a tower has been added over the right front door. (Submitted by Mary R. Conner of Accokeek.)

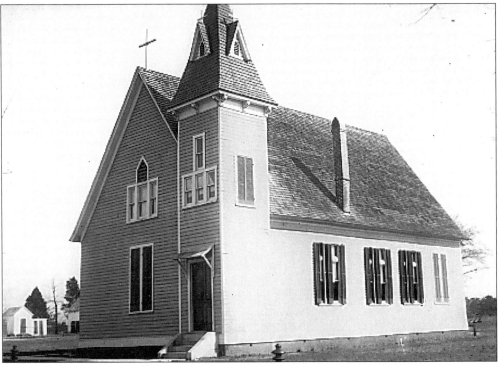

This is a photograph of the original St. John the Evangelist Catholic Church in Clinton *c.* 1915. (Submitted by Joan L. Chaconas, program assistant for the Surratt House Museum.)

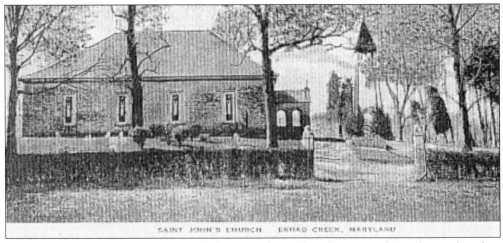

SAINT JOHN'S CHURCH BROAD CREEK, MARYLAND

This undated, hand-colored postcard of Saint John's Church in Broad Creek was found in drugstores and other places in the early 1940s. Note the absence of the 1932 Historical Marker, which means the photograph on the postcard was taken prior to that date. St. John's stands near the site of the early (now vanished) port town of Aire, surrounded by an ancient graveyard. This early Anglican (Episcopal) Church was built in 1766, the fourth church built on this site in Piscataway (King George's) Parish. This is the oldest (1695) church site in Prince George's County. (Submitted by Phyllis A. Luskey Cox of Oxon Hill; information obtained from the *Illustrated Inventory of Historic Sites in Prince George's County* by Maryland-National Capital Park & Planning Commission.)

Seven

SCHOOLS

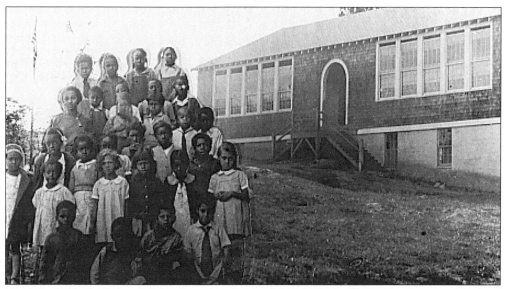

The Mitchellville Colored School was located at 2000 Mitchellville Road in Bowie and served children on surrounding farmland. The two-room school, photographed c. 1936, burned down, but the outhouse that students used is still there. Students in grades one through seven are pictured here with their teacher, Margaret Hill Stewart. They are, from left to right, (front row) Mano Cephas, Leo Fletcher, Calvin Blake, and Blake Jennings; (second row) Martha Deale Shepard, Agatha Mills (See), Hazel Butler (Harley), Delores Jackson (Henry), Josephine Williams (Coleman), and Helen Butler (Proctor); (third row) Mary Deale, Ellen Proctor (Shepard), unidentified, Alberta Wilson (Brown), Elzine Powell, and Dorothy Williams; (fourth row) Mrs. Margaret Hill Stewart, unidentified, Walter Jackson, Warren Mills, and Raymond Williams; (fifth row) Calvin Hall, Francis Hamilton, Eugene Fletcher, and Leonard Greene; (back row) Edward Proctor, Richard Proctor, Francis Wright, and unidentified. (Submitted by Bowie City Councilman Bill Aleshire, past member of the Prince George's County Historical & Cultural Trust, through the Prince George's Historical Society; courtesy of Hazel Butler Harley.)

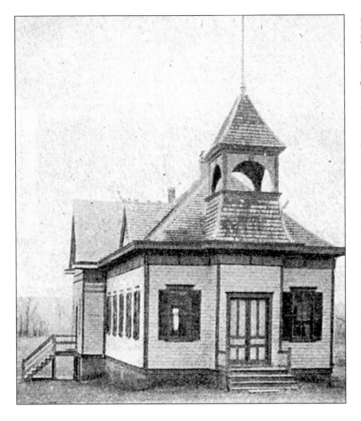

Riverdale Elementary School began in the early 1900s in a two-room building located near the Calvert Mansion in Riverdale Park. The land had been set aside by the Riverdale Park Company specifically for a school, in anticipation that it would attract young families to the town. At the time, the school was considered the best in Prince George's County, even with its tiny one-teacher, one-principal faculty. A pot-belly stove was fired up to keep the building warm during winter months. (Submitted by Riverdale Park mayor Ann Ferguson from the *Town of Riverdale, Maryland 1920–70*.)

The first Riverdale Elementary School's sanitary facility was of the outdoor type as shown in this photograph. (Submitted by Riverdale Park mayor Ann Ferguson from the *Town of Riverdale, Maryland 1920–70*; courtesy of J.W. Creegan.)

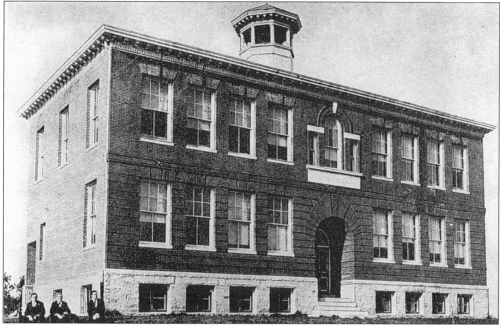

Laurel High School was built in 1899 as the first public high school in Prince George's County. Its construction was brought about by Edward Phelps, a seven-term mayor of Laurel. The school is a large 2.5-story, T-shaped brick building with (later) flanking hyphens and wings. Decorative details include a central Palladian-style window and molded string course and modillion cornice, as well as a handsome octagonal cupola. (Submitted by Kate Arbogast, Laurel Museum director, and Elizabeth Compton of the Laurel Museum and Historical Society; information obtained from the *Illustrated Inventory of Historic Sites in Prince George's County* by Maryland-National Capital Park & Planning Commission.)

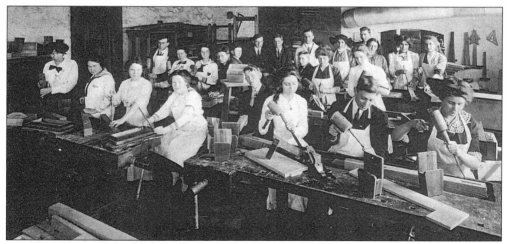

The Laurel High School manual arts class was photographed in 1914. The school is located at 701 Montgomery Street. (Submitted by Kate Arbogast, Laurel Museum director, and Elizabeth Compton of the Laurel Museum and Historical Society.)

Prior to 1910, the original Surrattsville School, the second-oldest school in Prince George's County, was a small frame building. The school was not too crowded at the time, so the one-room school building at Piscataway was abolished and those students transferred to Surrattsville. Many children walked long distances, rode horses, or came to school in horse-and-buggy fashion, these being the popular modes of transportation of the day. A small stable was provided at the school for feeding and sheltering the horses. In 1910, the larger frame building with six rooms shown in this c. 1920 photograph was built where the present auditorium stands. (Submitted by Joan L. Chaconas, program assistant for the Surratt House Museum.)

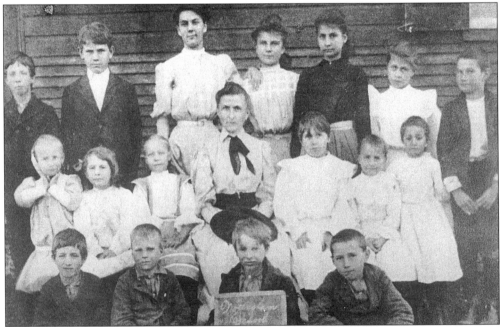

A class photograph of Nottingham School was taken in 1906. (Submitted by Susan Reidy, historian for the Natural and Historical Resources Division of Maryland-National Capital Park & Planning Commission.)

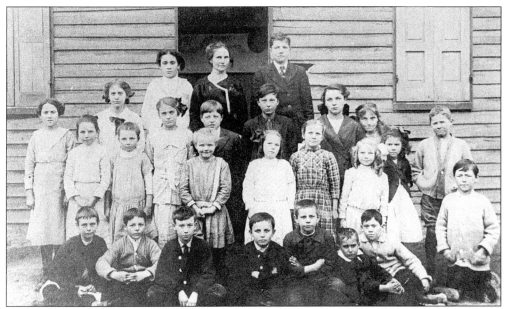

The old Brandywine School was photographed *c.* 1912–1915. Miss Minerva Robertson was the teacher. Included here are (front row) Lucy Robertson, Edward Early, Clifton Duvall, and Ham Meinhardt; (second row) Elise Taymans, Emily Early, Louise Robertson, and Mabel Boswell; (third row) Ola Boswell, Lonzo Early, and Ray Taymans; (back row) Mary Smith, Miss Minerva Robertson (teacher), and Joe Boswell. Also shown are Lucy, Emma, and Minnie Bronswage. (Submitted by Mary R. Conner of Accokeek.)

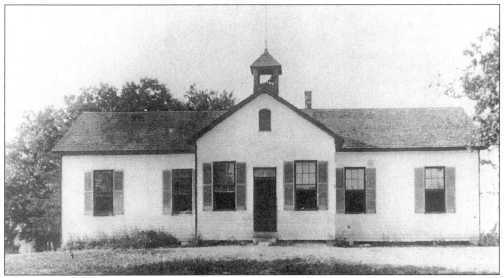

The Forestville School was photographed *c.* 1910. (Submitted by Susan Reidy, historian for the Natural and Historical Resources Division of Maryland-National Capital Park & Planning Commission; courtesy of Thomas Gwynn Jr.)

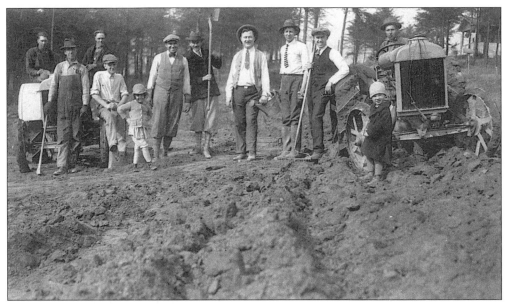

Members of the Cheverly-Tuxedo Citizens Association are shown at work on the Cheverly-Tuxedo School grounds in July 1927, under the direction of school trustee Raymond W. Bellamy Sr. (sixth from left). (Submitted by Raymond W. Bellamy Jr., town historian for the Town of Cheverly.)

A view looking north in early 1926 shows the two-room Cheverly-Tuxedo School that was completed in April 1923. Belleview Avenue is to the right. Robert Marshall, Cheverly's founder, donated eight lots to the board of education for its construction. (Submitted by Raymond W. Bellamy Jr., town historian for the Town of Cheverly.)

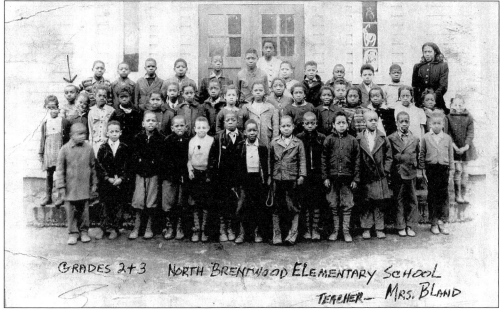

The North Brentwood Elementary School second and third grades of the 1945–1946 school year were photographed in front of the new school built in 1944. Mrs. Bland was their teacher. The importance of literacy was appreciated by old and young alike in North Brentwood and was reflected in the 93 percent of residents who indicated the ability to read and write in the 1920 census. The first classes were held in private homes. In 1910, the county provided a one-room building for use as a school. In 1925, a three-room public school was erected. (Submitted by North Brentwood mayor Lillian K. Beverly; information obtained from *Footsteps From North Brentwood: From Reconstruction to the Post World War II Years* by Dr. Frank H. Wilson.)

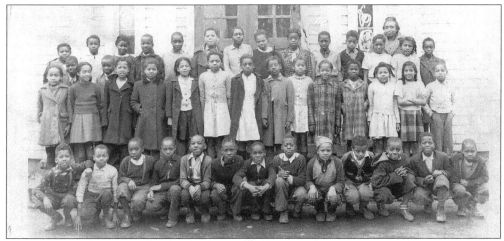

The third- to fifth-grade classes of North Brentwood Elementary School were photographed in 1946. The classes were taught by Mrs. Adela Hallman Johnson. The larger six-room school was built in 1944 during World War II and remained open until June 1969. Desegregation orders mandated from Upper Marlboro resulted in the school's closing, despite strong and organized community opposition. (Submitted by North Brentwood mayor Lillian K. Beverly; information obtained from *Footsteps From North Brentwood: From Reconstruction to the Post World War II Years* by Dr. Frank H. Wilson.)

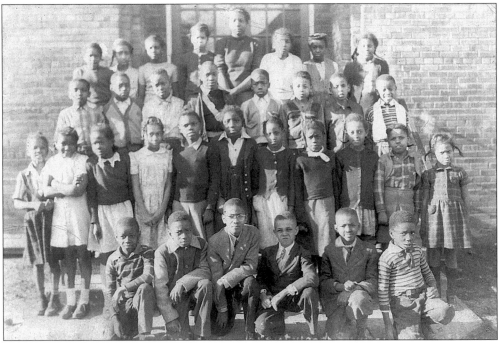

The fourth- and fifth-grade classes of North Brentwood Elementary School. The photograph was taken in front of the school during the school year 1945–1946. Resources distributed to the African-American schools were separate and unequal—materials, such as course texts, were always older, second-hand books that were passed down after white schools received new ones. Limited resources led to a great deal of improvisation. In addition to traditional drills, teachers inspired students through poetry, storytelling, orations, plays, and field trips. (Submitted by North Brentwood mayor Lillian K. Beverly; information obtained from *Footsteps From North Brentwood: From Reconstruction to the Post World War II Years* by Dr. Frank H. Wilson.)

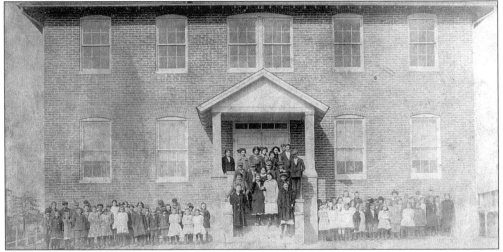

Bowie School opened in 1912, replacing the original wood-frame schoolhouse of the 1880s, which was located to the south on Chestnut Avenue. (Submitted by Susan Reidy, historian for the Natural and Historical Resources Division of Maryland-National Capital Park & Planning Commission.)

At the Bowie State commencement in 1954, Mrs. Margaret J. Thomas, left, moves forward to congratulate two graduates from North Brentwood. They are her son, Harrison Thomas, and Arthur J. Dock, former mayor of North Brentwood. (Submitted by North Brentwood mayor Lillian K. Beverly.)

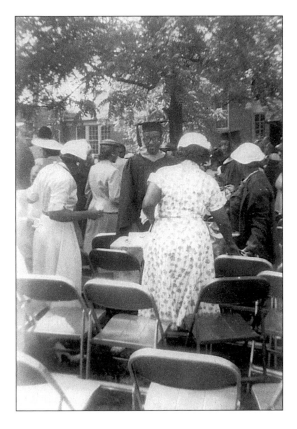

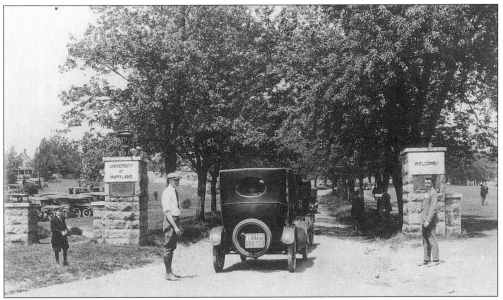

The entrance gates to the University of Maryland at Route 1 and College Avenue in College Park were photographed *c.* 1923. (Courtesy of the University of Maryland Libraries, Special Collections, and the Hughes Co.)

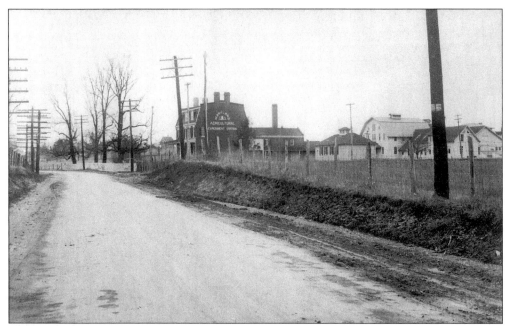

This *c.* 1910 photograph looking south along Route 1 (Baltimore Avenue) in College Park shows the Maryland Agriculture Experiment Station, which occupied the original Rossborough Inn. (Submitted by the Prince George's County Historical Society.)

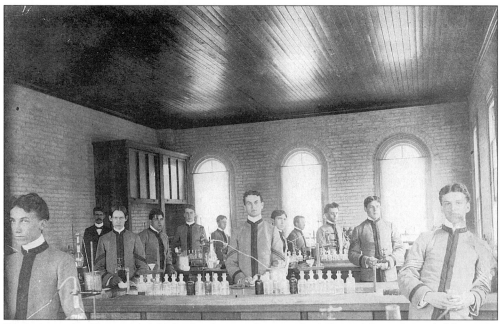

Students at the University of Maryland were photographed doing lab work, probably in the early 1900s. (Submitted by Katharine D. Bryant; courtesy of Isabel Symons Godwin, whose father Thomas B. Symons was the dean of agriculture, then on the board of regents, and acting president of the University of Maryland in the 1950s. Symons Hall was named after him.)

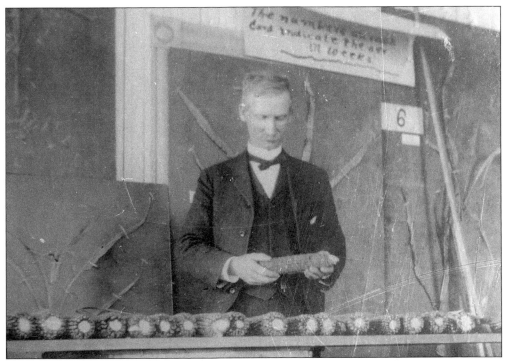

Dr. Warner T.L. Taliaferro, professor of agriculture at the Maryland Agricultural College (MAC, now the University of Maryland) from 1892–1936, is shown with a corn display at an agricultural event. A pioneer in the Farmers' Institute and with Extension work in Maryland, he inaugurated courses in practical agriculture and the agricultural sciences, including soils, crops, farm management, and accounting at MAC. He was the acting dean of the Division of Agriculture for MAC in 1916 and 1917 and the secretary-treasurer of the Maryland State Weather Service until 1923. (Submitted by Katharine D. Bryant, Taliaferro's great-niece.)

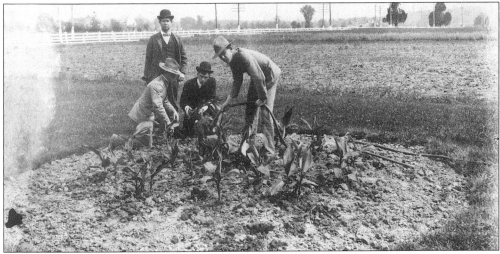

The junior class and Professor Austin planted "cannais" at the Maryland Agricultural College. The negative and print were copied from a glass negative. (Courtesy the University of Maryland Libraries, Special Collections.)

Agriculture livestock shows have been an important part of the University of Maryland's history. At this show, Miss Edith Farrington was the sweepstakes winner in the livestock fitting and showing contest. (Courtesy of the University of Maryland Libraries, Special Collections.)

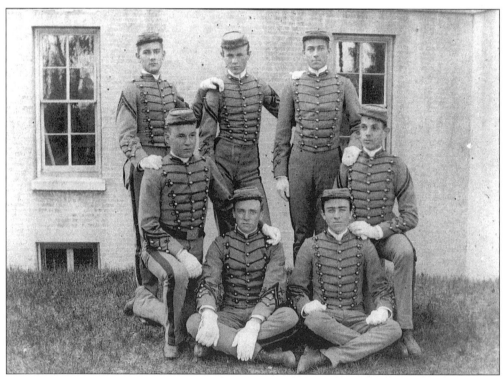

This photograph of Maryland Agricultural College cadets was taken in the early 1890s. From left to right are (seated) Richard C.M. Calvert and Robert G. Wilson; (kneeling) H. Burton Stevenson and C.C. Manning; (standing) C.E. Sales, R.L. Russell, and E.G. Niles. (Submitted by the Prince George's County Historical Society; courtesy of the McKeldin Library Archives, University of Maryland Libraries, Special Collections.)

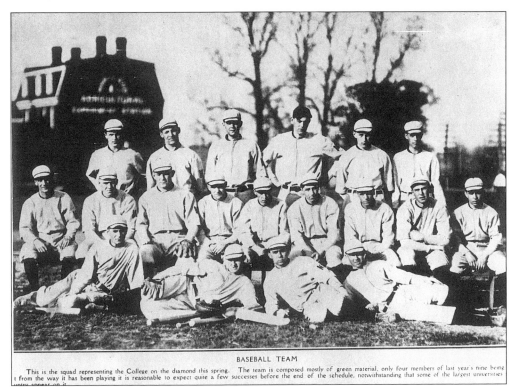

BASEBALL TEAM

This is the squad representing the College on the diamond this spring. The team is composed mostly of green material, only four members of last year's nine being back. But from the way it has been playing it is reasonable to expect quite a few successes before the end of the schedule, notwithstanding that some of the largest universities in the country appear on it.

The baseball team at the Maryland Agricultural College (now the University of Maryland) was photographed in 1915. According to a caption previously published with the photograph for the school, "This is the squad representing the College on the diamond this spring. The team is composed mostly of green material, only four members of last year's nine being back. But from the way it has been playing, it is reasonable to expect quite a few successes before the end of the schedule, notwithstanding that some of the largest universities in the country appear on it." (Courtesy of the University of Maryland Libraries, Special Collections.)

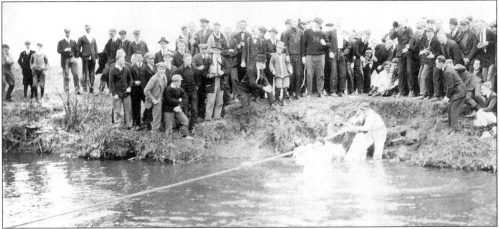

Students at the Maryland Agricultural College (now the University of Maryland) played tug of war on Paint Branch. The photograph was taken in 1916. (Courtesy of the University of Maryland Libraries, Special Collections, and K. Grace.)

Maryland Agricultural College.

ANNUAL COMMENCEMENT.

Friday, June 26th, 1863,

At 10 o'clock, A. M.

ORDER OF EXERCISES.

MUSIC.

PRAYER.

MUSIC.

FRENCH POEM...................*Beranger*.........HENRY USTICK ONDERDONK

MUSIC.

ABSALOM...................*Willis*............JOHN S. GITTINGS, JR.

MUSIC.

SPARTACUS TO GLADIATORS...*Epes Sargeant*...W. T. S. TURPIN.

MUSIC.

BRITISH AGGRESSION..........*Patrick Henry*..JOSHUA N. WARFIELD.

MUSIC.

GREEK RECITATION...............*Bible*.............S. D. HALL.

MUSIC.

ORATION*Otis*.........J. W. IGLEHART.

MUSIC.

CATILINE TO HIS ARMY.......*Croly*.............C. H. R. MERRICK.

MUSIC.

ALFRED TO HIS MEN..........*Knowles*..........E. S. CALVERT.

MUSIC.

Original Theses.

LOCOMOTIONWILLIAM B. TODD, JR.

MUSIC.

OBSERVATION AND VALEDICTORY...............C. B. CALVERT, JR.

MUSIC.

Testimonials Awarded—Degrees Conferred.

MUSIC.

ADDRESS, by..............................Rev. B. B. GRISWOLD.

MUSIC.

Benediction

This program illustrates the order of the Annual Commencement Exercises at the Maryland Agricultural College on Friday, June 26, 1863. (Submitted by the Prince George's County Historical Society.)

Eight
EARLY RESIDENTS

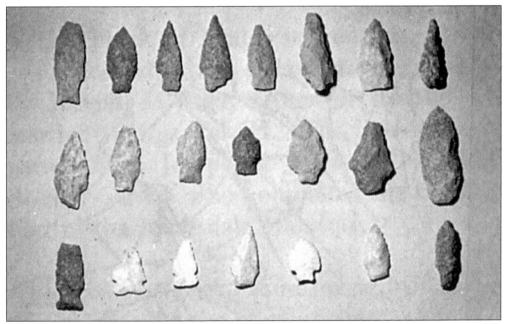

There is abundant evidence in the form of unearthed artifacts that Native Americans either passed through the Riverdale Park and College Park area frequently, or perhaps lived there. The above artifacts were found in the Town of Riverdale Park by Robert G. Fuerst. The arrowheads and tools are believed to have been used by Native Americans who lived during the Woodland period. For the most part they have been unearthed in flowerbeds and gardens of Riverdale Park residents. Street names such as Powhatan in Riverdale Park and College Park echo the past. Route 1 through Prince George's County was originally an Indian trail, and Paint Branch Creek through College Park got its name because Native Americans used the red clay for paint.

In the early 1900s, a large intact Native American pot was found in the backyard of 7406 Columbia Avenue, College Park, the current home of Katharine D. Bryant and her brother, George Bryant. In the tradition of families at that time, the pot was given to Edward Johnson, the oldest son of John Oliver Johnson, who founded College Park in 1890. Edward Johnson never lived at this address, but his sister, Emily Johnson, did, as the wife of Warner Taliaferro, a professor at the University of Maryland. Edward Johnson went on to become minister of St. Anne's Episcopal Church in Annapolis for 38 years.

There is ample evidence of the American Indian presence throughout Prince George's County, and the *Illustrated Inventory of Historic Sites* by the Maryland-National Capital Park & Planning Commission has identified two American Indian archeological sites. One is Nottingham Archeological Site in Nottingham. The occupation of this site was between 500 B.C. and 1600 A.D. This prehistoric site comprises a middle and late Woodland village and is possibly the site of the Native American village indicated on Captain John Smith's 1608 map. The other is Accokeek Creek Archeological Site on Bryan Point Road. Its occupation was between 3000 B.C. and the seventeenth century A.D. This prehistoric site includes the area occupied by archaic and Woodland people within present-day Piscataway Park. It is an important source of information about the Piscataway Indians at the time of the arrival of European settlers.

Prince George's County's Native American Past

At the time of European contact, the Piscataway Indians held sway over a loose confederation of Native American groups along the Potomac River in Southern Maryland. It has been estimated that their real power in the area dated from 800 A.D. onwards, and that their decline as a regional force was well under way by the early 1600s. They were in charge of a loosely knit smattering of tribes that included the Anacostan, Mattawoman, Nanjemoy, and Portobaco. Their biggest worries, up to the time of English colonization, were the powerful Susquehannas and Five Nations to the north, and Powhatan's considerable confederacy of Indian nations to the south.

These tribes occupied prime riverfront lands stretching from the Anacostia River down the main stem of the Potomac, with camps in places like Accokeek and Nanjemoy, where the river loops from a southern to an easterly route, emptying into the Chesapeake Bay about 60 miles further on. They subsisted on agriculture and as mariners of the river, and by all accounts, food and resources were plentiful.

Each tribe had a Tayac, which early explorers misinterpreted as "Emperor." In fact, a Tayac was a local chief and emissary to the confederation.

A peace treaty was signed by a dozen Native American groups throughout this area in 1666. The agreement arranged for them to retain their lands while Maryland colonists could move into unoccupied areas and, presumably, encroach upon areas where no agreements were in place. Within two years, these boundaries were further defined, creating in effect a reservation that stretched along the Potomac River between Mattawoman and Piscataway Creeks. Most of this land today comprises Piscataway Park, administered by the National Park Service.

Typically, treaties were frequently broken, rewritten, then broken again. Over the next quarter century, pressure would build as land-hungry settlers eyed this prime real estate along the river. Incidents occurred; sometimes the Piscataways were falsely accused of attacking whites (such as happened in Virginia and led to the siege and burning of the Moyoane Indian stockade). Eventually the movement of European immigration became overwhelming, and the Piscataway Indians would be forced off these lands. They moved across the river to Virginia or north toward Pennsylvania. By the early 1700s, the entire area had been taken for settlement.

By Stephen Colton of Indian Head

John William Wheatley owned the Surratt House in Clinton from 1890 to 1915. (Submitted by Joan L. Chaconas, program assistant for the Surratt House Museum.)

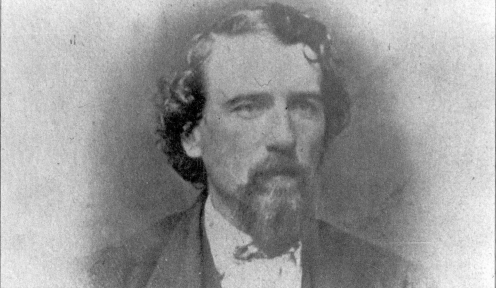

Thomas Harbin was a critical member of the Confederate underground movement in Southern Maryland. He would play a role in the kidnap/assassination conspiracy against President Abraham Lincoln. At the beginning of the Civil War, he owned the Piscataway Tavern, now a historic site in Prince George's County. (Submitted by Joan L. Chaconas, program assistant the Surratt House Museum.)

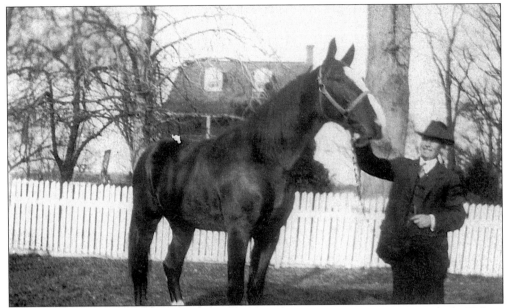

Frank A. Robinson was photographed with his race horse, "Hal Hardin," at Black Walnut Thicket in Baden. The photograph was taken prior to 1929. (Submitted by Mary R. Conner of Accokeek.)

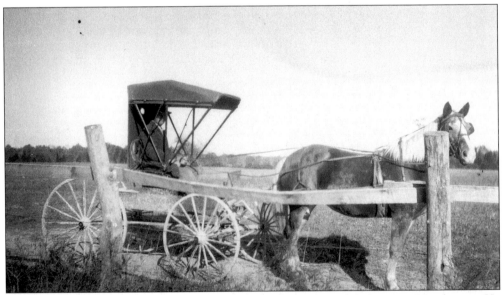

Robert H. Robinson was shown with his horse, "Lady," at Ferndale Farm in Brandywine. He rode his horse to the village daily. The photograph was taken in the 1920s. (Submitted by Mary R. Conner of Accokeek.)

Robert Henry Robinson (1851–1937) served as a deputy inspector at the State Tobacco Warehouse in Baltimore for eight years. He was also a member of the board of directors of the Bank of Brandywine. He lived and farmed at Brandywine. (Submitted by Mary R. Conner of Accokeek.)

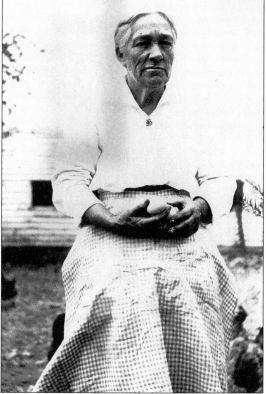

Amanda B. Robinson carried eggs in the hen yard of the Ferndale Farm near T.B. The photograph was taken by her daughter Lucy R. Arth of Washington, D.C. in the 1920s. (Submitted by Franklin A. Robinson Jr. of Benedict; courtesy of Robinson-Via Family Papers, NMAH, Archives Center, Smithsonian Institution.)

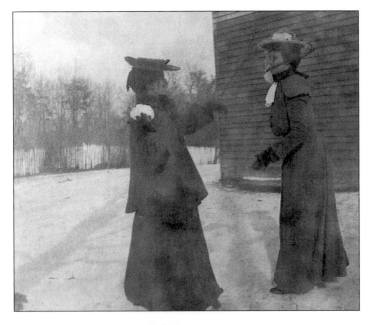

Two of the Reverend Mr. Francis P. Willes's sisters engage in an early-twentieth-century snowball fight at the rectory of St. Thomas' Episcopal Parish in Croom. (Submitted by Franklin A. Robinson Jr. of Benedict; courtesy of St. Thomas' Parish Archives.)

The Reverend Mr. Francis P. Willes and one of his sisters re-enact handing off the mail pouch on the porch of the rectory of St. Thomas' Episcopal Parish in Croom. (Submitted by Franklin A. Robinson Jr. of Benedict; courtesy of St. Thomas' Parish Archives.)

Dr. Warner T.L. Taliaferro and his wife, Emily (Johnson), of College Park are shown riding bicycles in the early 1900s. Dr. Taliaferro was a professor of agriculture at the Maryland Agricultural College (MAC, now the University of Maryland) from 1892 to 1936 and the acting dean of the Division of Agriculture for MAC in 1916 and 1917. Taliaferro first served the state of Maryland as a teacher in the old Bel Air Academy and as the editor of the *Harford Democrat* from 1881 to 1892. Emily was the daughter of John Oliver Johnson, who founded College Park. (Submitted by Katharine D. Bryant.)

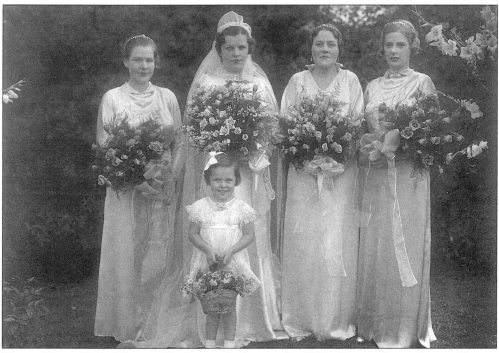

The wedding of Isabel Symons Godwin took place in the 1930s. During this garden wedding in College Park, a train went by and temporarily stopped the ceremony. On the left is Isabel's sister Jo, and on the right is her sister Helen. Katharine "Kitty" Smith, to the far right, was the granddaughter of John Oliver Johnson, founder of College Park. Isabel's father was the dean of agriculture at the University of Maryland, on the board of regents, and the acting president of the University of Maryland during the 1950s. (Submitted by Katharine D. Bryant; courtesy of Isabel Symons Godwin.)

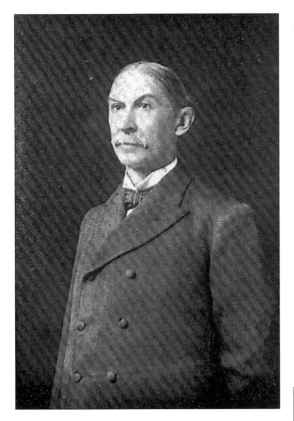

John Oliver Johnson was the founder of College Park in 1890. In the mid-1800s, it became fashionable to escape the extreme heat and humidity of the swampy atmosphere of Washington, D.C. during the summers. Johnson, a Washington real estate developer, chose to take the train out to College Station, formerly a hog yard on bottom land. He purchased the 125 acres from Ella Calvert Campbell, named the town College Park, drained the land, and subdivided and platted the streets and village lots in what is now Old Town. Johnson was also a German Reformed minister who founded St. Andrew's Episcopal Church in College Park by giving the barn on the property (now the Parish Hall at Dartmouth and Knox) for church services. (Submitted by Katharine D. Bryant, his great granddaughter.)

This 1940 family photograph shows the former North Brentwood mayor Sandy B. Johnson (in white). With him are his brothers, Silas (top) and Inman (middle), in the yard of their North Brentwood home. (Submitted by North Brentwood mayor Lillian K. Beverly.)

The Reverend William H. Thomas and Mack Brown are shown talking outside the Thomas yard in North Brentwood. The house in the background was an original Randall Town House on Meadow Avenue, which is now Windom Road. (Submitted by North Brentwood mayor Lillian K. Beverly; courtesy of Eleanor Traynham.)

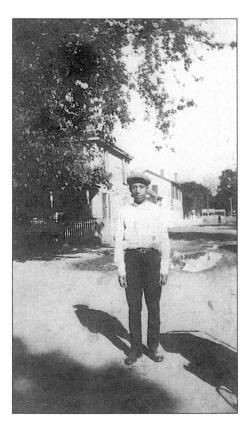

Hammond Thomas is photographed standing in the middle of School Street near the James and Virginia Holmes House in North Brentwood. (Submitted by North Brentwood mayor Lillian K. Beverly; courtesy of Eleanor Traynham.)

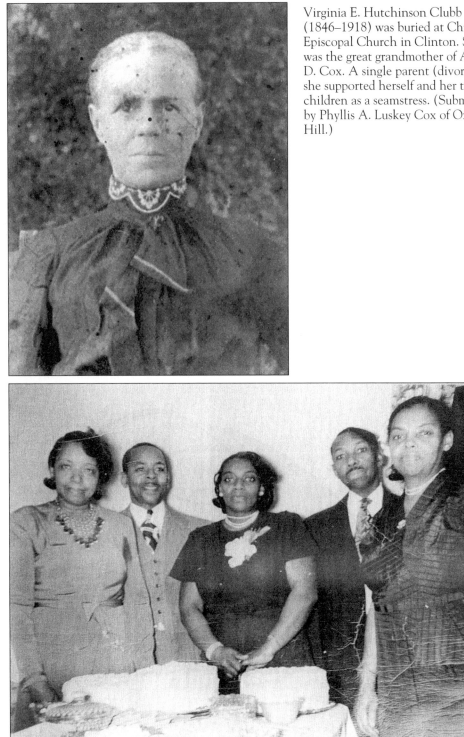

Virginia E. Hutchinson Clubb (1846–1918) was buried at Christ Episcopal Church in Clinton. She was the great grandmother of Arthur D. Cox. A single parent (divorced?), she supported herself and her two children as a seamstress. (Submitted by Phyllis A. Luskey Cox of Oxon Hill.)

The Charles B. Tilghman siblings of North Brentwood were photographed together. (Submitted by North Brentwood mayor Lillian K. Beverly; courtesy of Bettye Queen.)

James Richard Cadell (1882–1945) of Broad Creek was known as "Captain Dick" because he did dredging on the water as a waterman. This photograph was taken prior to 1909. (Submitted by his granddaughter, Phyllis A. Luskey Cox of Oxon Hill.)

In the background of this photograph is a house that was rented by the Roy Perrygo family, who operated a store that later became the infamous "Bucket of Blood" Tavern. This Easter scene was photographed around 1932 in Oxon Hill at the Washington, D.C. line. Bernard, Arthur, and Joe Cox were photographed wearing white suits made by their mother, Mabel Hill Cox. Seen very faintly in the distance, at the top of the hill on the right, is the home of Alfred Hayes in Washington, D.C. (Submitted by Phyllis A. Luskey Cox. of Oxon Hill.)

Taken around 1942, this photograph of Phyllis A. Luskey Cox, shows the home of her great-grandparents John William (1844–1894) and Alice Virginia Piles Cadle (1856–1928) in the background. The house was located on the Battersea/Harmony Hall tract in Broad Creek. The location of the tree and other items is now a little west of Livingston Square Shopping Center. (Submitted by Phyllis A. Luskey Cox of Oxon Hill.)

Sheriff's Garage was located on Livingston Road in Oxon Hill and was operated by Thomas Sheriff until 1993. This photograph was taken sometime around 1948. (Submitted by his son, James Sheriff Sr. of Oxon Hill.)

Nine

BUSINESSES

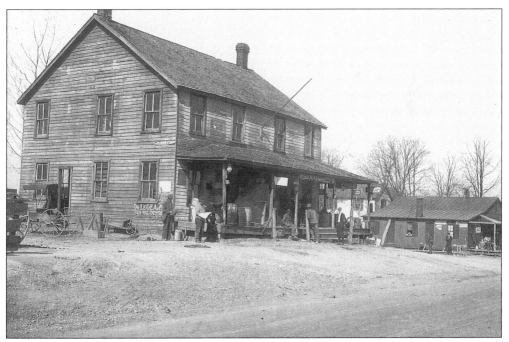

The General Store in Clinton was a popular hangout for residents *c.* 1914. This building stood at the intersection of modern-day Brandywine and Piscataway Roads, across from the historic Surratt House. It remained in existence through the 1950s. (Submitted by Joan L. Chaconas, program assistant for the Surratt House Museum.)

Bealls Dry Goods Store was located on Main Street in Laurel. This photograph was taken c. 1910. (Submitted by Kate Arbogast, Laurel Museum director, and Elizabeth Compton of the Laurel Museum and Historical Society.)

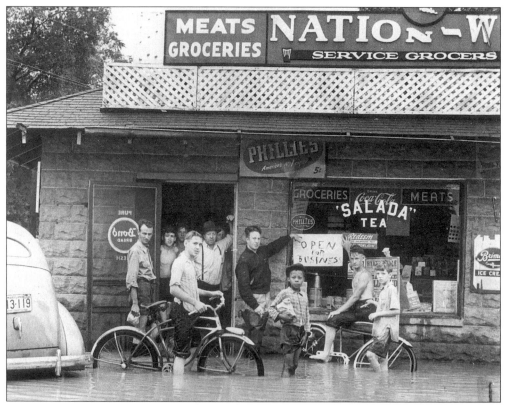

Major flooding occurred in the Town of Edmonston in 1943, when this photograph was taken. The water level was halfway up the wheels on the bicycles in front of the local grocery store. The store was located on Taylor Road near Decatur Street. (Submitted by B. Adele Compton, clerk-treasurer for the Town of Edmonston.)

Albrecht's Pharmacy was located at Route 1 (Baltimore Avenue) and College Avenue in College Park. Students from the Maryland Agricultural College (now the University of Maryland) used to hang out in the booths at the back of the store. The store was a popular place for children to buy candy and was located in what was reputed to be the first shopping center in Prince George's County. Although the building and shop still exist, Albrecht's has gone out of business. (Submitted by the Prince George's County Historical Society.)

Wells Pharmacy in Riverdale Park no longer exists. (Submitted by Susan Reidy, historian for the Natural and Historical Resources Division of Maryland-National Capital Park & Planning Commission.)

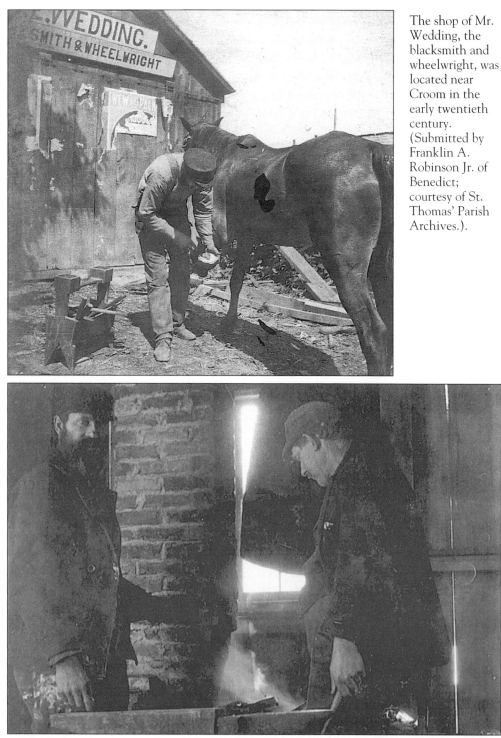

The shop of Mr. Wedding, the blacksmith and wheelwright, was located near Croom in the early twentieth century. (Submitted by Franklin A. Robinson Jr. of Benedict; courtesy of St. Thomas' Parish Archives.).

Mr. Wedding, the blacksmith, was photographed with his assistant. They plied their trade in the Wedding blacksmith and wheelwright shop near Croom in the early twentieth century. (Submitted by Franklin A. Robinson Jr. of Benedict; courtesy of St. Thomas' Parish Archives.)

This blacksmith shop was located in Clinton c. 1915. (Submitted by Joan L. Chaconas, program assistant for the Surratt House Museum.)

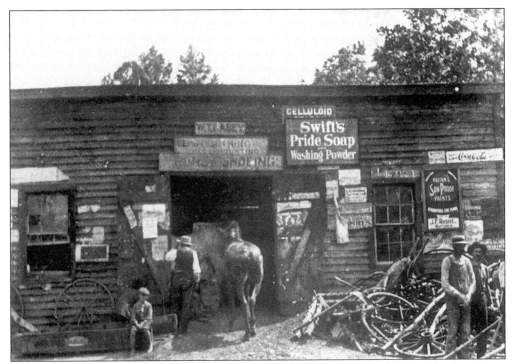

Casey's Blacksmith Shop in Bladensburg was typical of the time. (Submitted by the Prince George's County Historical Society.)

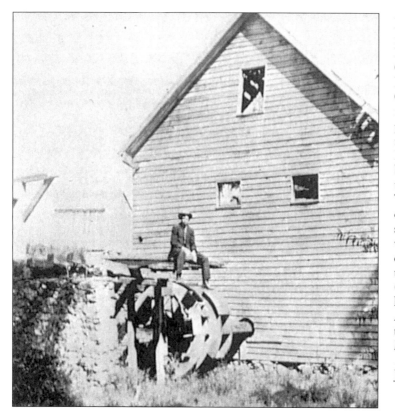

Mowatt's Mill, at the intersection of Good Luck Road (old Calvert Road) and Edmonston Road in College Park, appears in this 1905 photograph. The mill race exists no longer. It was a grist mill below the fall from the Piedmont to the Tidewater, but it only operated sporadically whenever there was enough rain to push the mill wheel. (Submitted by Riverdale Park mayor Ann Ferguson from the *Town of Riverdale, Maryland 1920–70*; courtesy of James C. Wilfong Jr.)

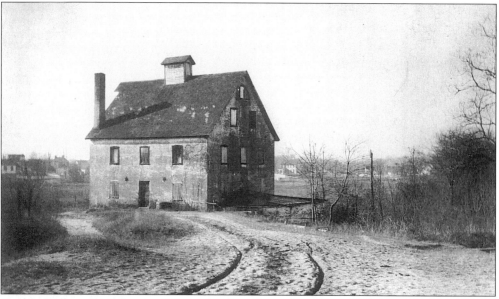

Avalon Mill was built by the Calvert family and was located in Bladensburg off Edmonston Road. It was torn down in 1929. (Submitted by Susan Reidy, historian for the Natural and Historical Resources Division of Maryland-National Capital Park & Planning Commission; courtesy of S.K. Cristofane.)

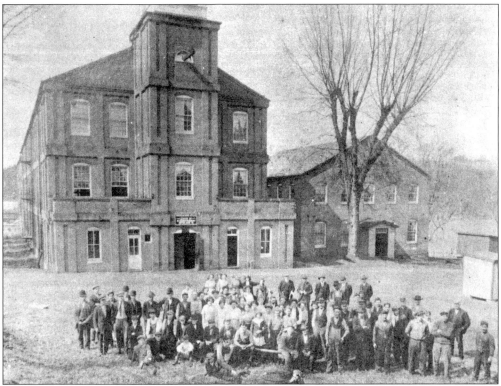

Laurel Cotton Mill was the focal point of Laurel's industry for a century. (Submitted by the Prince George's County Historical Society.)

Willard Allen Harris Sr. (1912–1993) operated a Gulf gas station in Cottage City sometime in the 1940s. He was photographed wiping the windshield of a car. (Submitted by his daughter Barbara Harris Herbert of Coltons Point.)

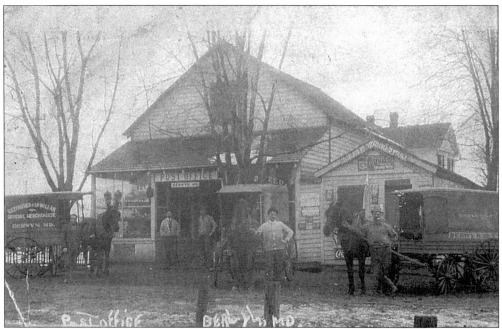

The old Berwyn Heights Post Office was photographed when mail was delivered by horse and buggy. (Submitted by Susan Reidy, historian for the Natural and Historical Resources Division of Maryland-National Capital Park & Planning Commission.)

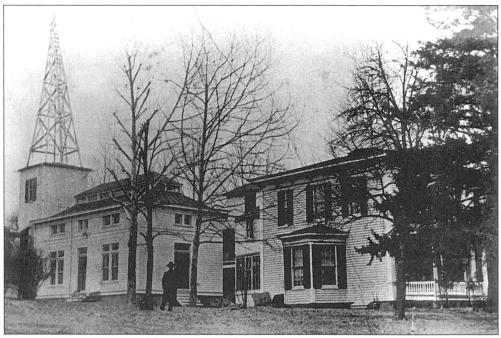

Rogers' Wireless Station and residence in Hyattsville no longer exist. (Submitted by Susan Reidy, historian for the Natural and Historical Resources Division of Maryland-National Capital Park & Planning Commission.)

Ten

PUBLIC SAFETY AND SERVICE

Charles Bernard "Bernie" Tilghman Sr. was the first African-American sheriff in Maryland, as well as in Prince George's County. This photo of him was taken in approximately 1937. His granddaughter Bettye Queen recalled that "whenever there would be an altercation in North Brentwood or black areas, he would be called. He would put you on the streetcar and take you up to Hyattsville jail." (Submitted by North Brentwood mayor Lillian K. Beverly; courtesy of Bettye Queen; information obtained from *Footsteps From North Brentwood: From Reconstruction to the Post World War II Years* by Dr. Frank H. Wilson.)

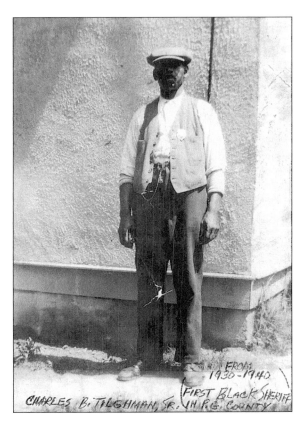

FROM 1930-1940

FIRST BLACK SHERIFF

CHARLES B. TILGHMAN, SR. IN P.G. COUNTY

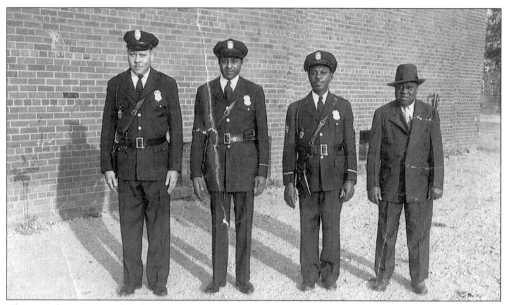

The North Brentwood Police Force was photographed with Mayor William Bellows in the late 1940s. The policemen are, from left to right, "Reds" Tolson, Madison Brown, and Stanley Queen. The police, justice of the peace, and fire department were established before the town's incorporation in 1924. The police department, consisting of a police chief and part-time officers, lasted until the late 1960s. (Submitted by North Brentwood mayor Lillian K. Beverly; courtesy of Stanley Queen; information obtained from *Footsteps From North Brentwood: From Reconstruction to the Post World War II Years* by Dr. Frank H. Wilson.)

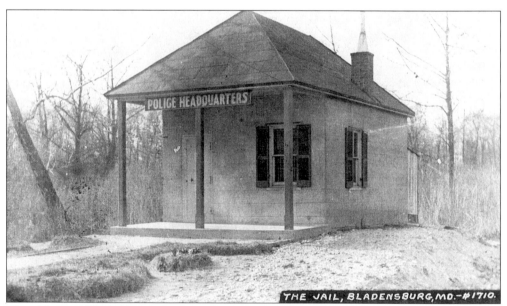

The old jail in Bladensburg, which has been destroyed, was pretty small. (Submitted by Susan Reidy, historian for the Natural and Historical Resources Division of Maryland-National Capital Park & Planning Commission.)

Working on the new Capitol Heights Fire Station in the late 1940s are, from left to right, Walter Curley, Audrey Miller, and Bill Devine. (Submitted by Mark Brady, press information officer, and Diane Cunningham, administrative aide, from the Office of the Fire Chief, Prince George's County; courtesy of Capitol Heights Volunteer Fire Department.)

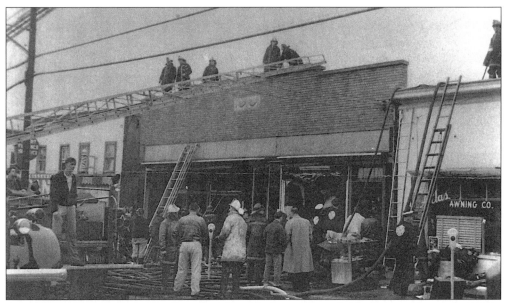

A multiple-alarm fire went off at Ben Franklin's in Capitol Heights in the early 1950s. (Submitted by Mark Brady, press information officer, and Diane Cunningham, administrative aide, from the Office of the Fire Chief, Prince George's County; courtesy of Capitol Heights Volunteer Fire Department.)

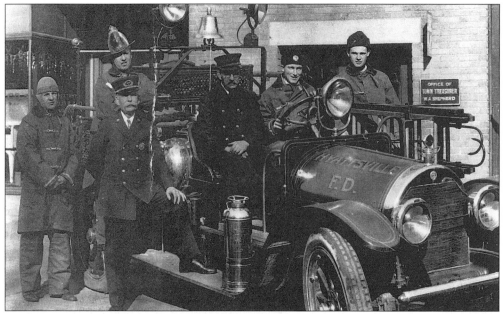

A 1926 photo was taken of the Cadillac Hose Wagon in Hyattsville. From left to right are B. Harrison, ? Dearstine, B.E. McCann, John Fainter Jr., J.L. Sullivan, and A. Degges. (Submitted by Mark Brady, press information officer, and Diane Cunningham, administrative aide, from the Office of the Fire Chief, Prince George's County; courtesy of George Wilcoxen.)

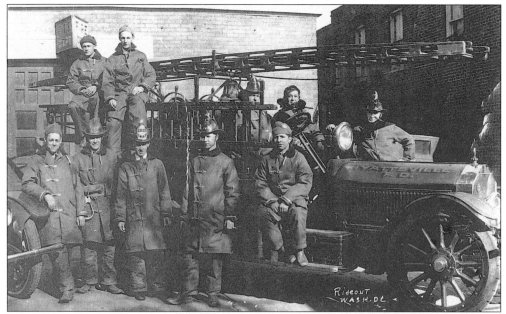

This 1925 American LaFrance 350 engine used by the Hyattsville Fire Department was photographed in 1926. From left to right are George Wilcoxen, W.B. Harrison, N. Rushe, T. Latimer (seated on the rear of engine), W. Richards (seated on the rear of engine), R. Johnson, C. Johnson, H. Wilcoxen, and M. Levin. (Submitted by Mark Brady, press information officer, and Diane Cunningham, administrative aide, from the Office of the Fire Chief, Prince George's County; courtesy of George Wilcoxen.)

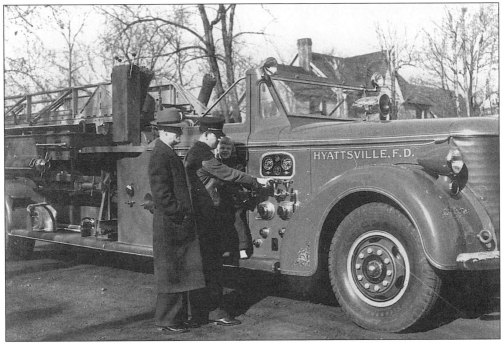

Chief Davis showed off the Hyattsville Fire Department's 1941 American LaFrance quint-ladder truck to Mayor Gover and his granddaughter Marie Drinkard. (Submitted by Mark Brady, press information officer, and Diane Cunningham, administrative aide, from the Office of the Fire Chief, Prince George's County; courtesy of F.X. Geary.)

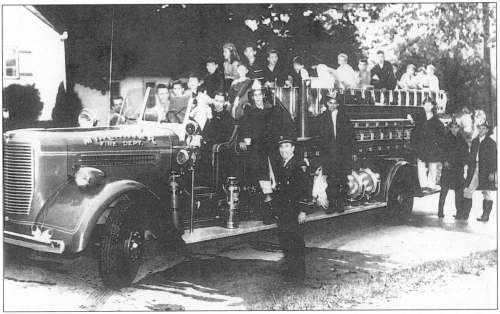

Unknown members of the Mount Rainier Fire Department were photographed with the 1940 Peter Pirsch 65-foot Aerial Ladder Truck. (Submitted by Mark Brady, press information officer, and Diane Cunningham, administrative aide, from the Office of the Fire Chief, Prince George's County.)

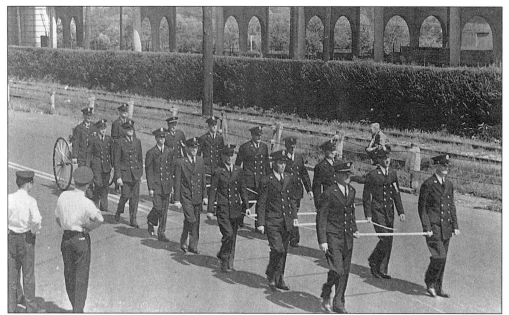

Members of the Riverdale Volunteer Fire Department paraded through Hyattsville, while pulling their hose reel. (Submitted by Mark Brady, press information officer, and Diane Cunningham, administrative aide, from the Office of the Fire Chief, Prince George's County; courtesy of F.X. Geary.)

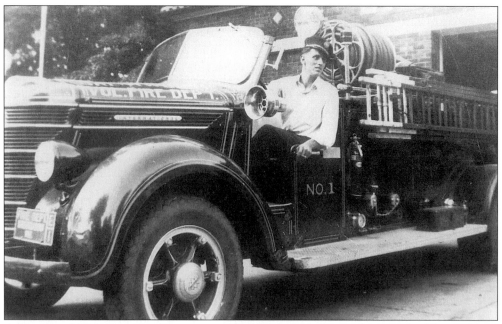

A Brentwood Volunteer Fire Department 1939 International was photographed being driven by Ralph Collins. (Submitted by Mark Brady, press information officer, and Diane Cunningham, administrative aide, from the Office of the Fire Chief, Prince George's County; courtesy of Ralph Collins.)

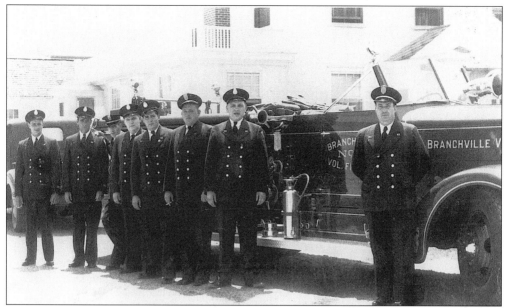

Standing in front of a Branchville Fire Department 1944 American La France are, from left to right, Cleveland Fleshman, James Melton, Carl Leser, Bill Fleshman, Rodney Leser, Joseph Porter, Robert Shipley, and Frank Leser. (Submitted by Mark Brady, press information officer, and Diane Cunningham, administrative aide, from the Office of the Fire Chief, Prince George's County; courtesy of Richard Hughes.)

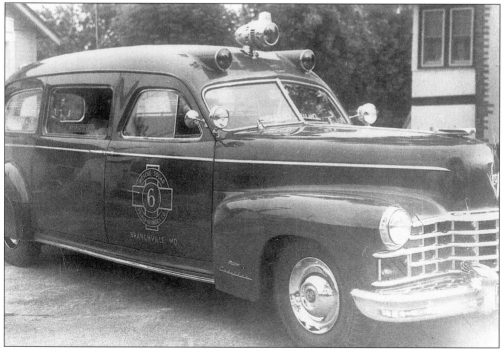

This is a Branchville Fire Department 1948 Cadillac Rescue Squad. (Submitted by Mark Brady, press information officer, and Diane Cunningham, administrative aide, from the Office of the Fire Chief, Prince George's County; courtesy of Richard Hughes.)

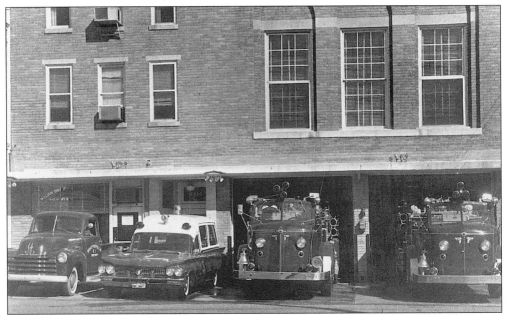

Some equipment from the early 1950s was still being used by the Hyattsville Volunteer Fire Department in 1960. From left to right are a 1950 Chevrolet pickup; a 1960 ambulance (No. 18); a 1952 1,000-gallon American LaFrance pumper (Engine 12); and a 1951 1,000-gallon American LaFrance pumper (Engine 13). (Submitted by Mark Brady, press information officer, and Diane Cunningham, administrative aide, from the Office of the Fire Chief, Prince George's County; courtesy of F.X. Geary.)

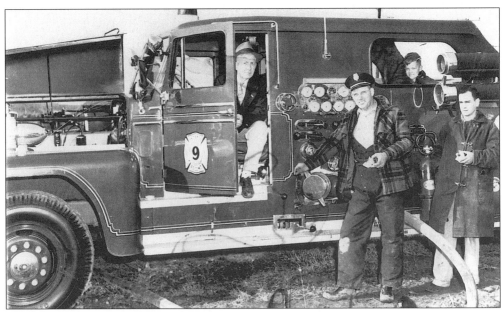

Members of the Bladensburg Volunteer Fire Department were photographed with the Oren pumper. (Submitted by Mark Brady, press information officer, and Diane Cunningham, administrative aide, from the Office of the Fire Chief, Prince George's County; courtesy of the Bladensburg Volunteer Fire Department.)

Maryland Minute Men
Reserve Militia

To all who shall see these presents, greeting:

KNOW YE, that reposing special trust and confidence in the fidelity and abilities of *Irving W. Luskey Jr.* I do hereby appoint him *Corporal* Co. 927 **MARYLAND MINUTE MEN, RESERVE MILITIA,** to rank as such from the 22 day of *January* one thousand nine hundred and *Forty Three.* He is therefore carefully and diligently to discharge the duty of *Corporal* by doing and performing all manner of things thereunto belonging. And I do strictly charge and require all Non-Commissioned Officers and Soldiers under his command to be obedient to his orders as *Corporal.* And he is to observe and follow such orders and directions from time to time, as he shall receive from his Superior Officers and Non-Commissioned Officers set over him, according to the rules and discipline of War.

GIVEN under my hand at *Hyattsville, Md.* this 22 day of *January* in the Year of our Lord one thousand nine hundred and *Forty Three*

Caesar L. Aiello

LT. COLONEL CAESAR L. AIELLO
NINTH BATTALION, COMMANDING

This certificate is the appointment of Irving W. Luskey Jr. of Oxon Hill as corporal of Co. 927 of the Maryland Minute Men Reserve Militia on January 22, 1943. (Submitted by Phyllis A. Luskey Cox of Oxon Hill.)

The Maryland Minute Men were the home guard established to protect citizens during World War II, in case the continent was invaded. This photograph of Prince George's County's Maryland Minute Men Reserve Militia, Co. 927, was taken prior to September 1944 by Underwood & Underwood of Washington, D.C. Those identified in the photograph are (second row, second from left) soldier Irving William Luskey Jr. (1911–1987), the father of Phyllis A. Luskey Cox of Oxon Hill, who submitted the photograph; and (third row, second from left) soldier Robert Edward "Eddie" Powell, who graduated from Oxon Hill High School in June 1944, was drafted into the Army in September 1944, and died of battle wounds in March 1945. Luskey and Powell were neighbors in Broad Creek.

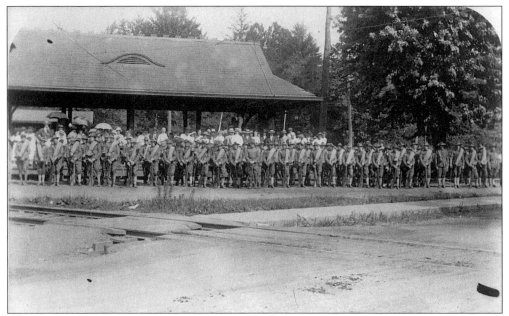

Company F cadets of the National Guard stood at the Hyattsville train station. This photo was taken on July 13, 1913 as the cadets prepared to leave for the Mexican border. (Submitted by the Prince George's County Historical Society.)

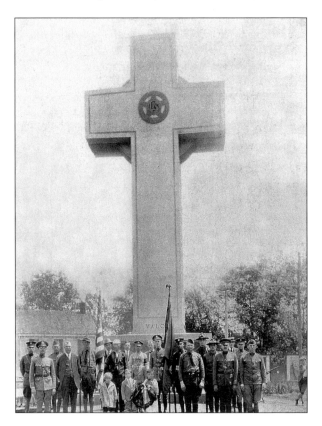

A collection of various war veterans posed together in front of Peace Cross in Bladensburg. (Submitted by Susan Reidy, historian for the Natural and Historical Resources Division of Maryland-National Capital Park & Planning Commission.)

Eleven
SOCIAL ACTIVITIES

The University of Maryland football game in October 1957 was known as the Queen's Game. From left to right are Coach Tommy Mont, Queen Elizabeth II, Governor Theodore R. McKeldin, and Prince Phillip, Duke of Edinburgh. (Submitted by the Prince George's County Historical Society.)

Omaha, a Triple Crown winner, is shown with jockey Willie Saunders at Belmont Stakes, in June 1935. The Belair Stud was the only stable to produce father-son Triple Crown winners: Gallant Fox and Omaha. (Submitted by Stephen Patrick, curator of the City of Bowie Museums.)

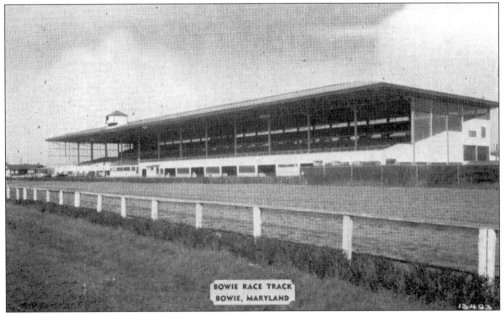

"Bowie Racetrack/Bowie, Maryland" is a c. late 1930s postcard. The postcard was one of series of Bowie scenes created at the time. (Submitted by Stephen Patrick, curator of the City of Bowie Museums.)

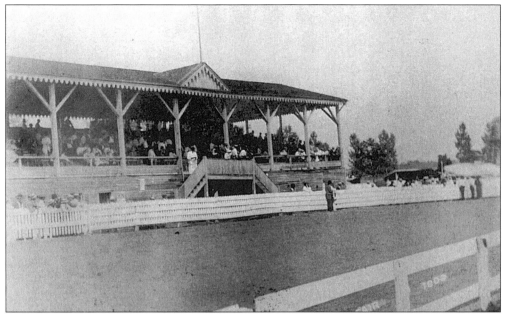

Prince George's County Fairgrounds existed in Upper Marlboro as far back as 1909, when this photograph was taken. The Marlboro Fair took place there even then. (Submitted by Susan Reidy, historian for the Natural and Historical Resources Division of Maryland-National Capital Park & Planning Commission.)

Judges inspected tobacco at the 1929 Prince George's County Fair in Upper Marlboro. (Submitted by Susan Reidy, historian for the Natural and Historical Resources Division of Maryland-National Capital Park & Planning Commission; courtesy of Enoch Pratt Free Library.)

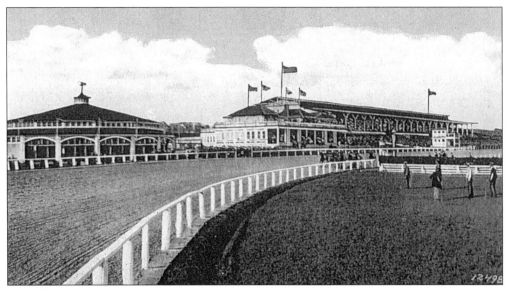

This photograph shows Laurel Race Track, which came into existence in 1911, when the Maryland State Fair was incorporated and purchased the 320 acres of land. History has it that the horse races were part of the state fair. Now the track is known for the Washington, D.C. International Race that's held every November. Horses that are run in that race come from all over the world. (Submitted by Kate Arbogast, Laurel Museum director, and Elizabeth Compton of the Laurel Museum and Historical Society.)

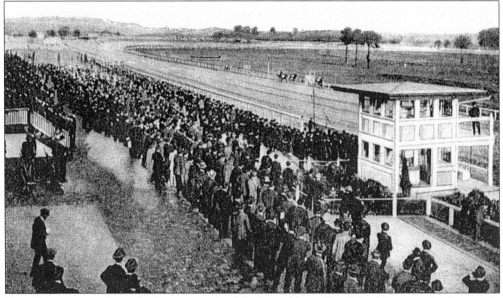

Horses are coming down the home stretch of the Laurel Race Track in this scene. In those early days, men were dressed up in business suits when they crowded the fence at the races, which were only run in October. In January 1918, the Laurel Race Track was turned over to the War Department for the training of engineer units before their transfer to France. Officers used the clubhouse for headquarters, and the jockeys' clubhouse was used as a hospital for the Engineer Corps. (Submitted by Kate Arbogast, Laurel Museum director, and Elizabeth Compton of the Laurel Museum and Historical Society.)

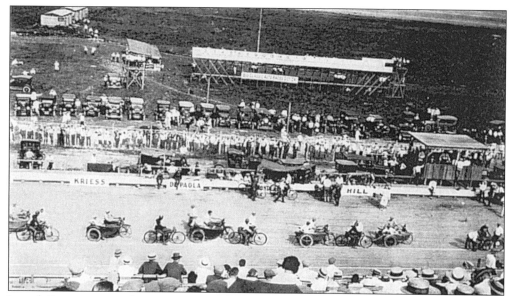

Laurel Raceway served as an automobile race track for one season only. In 1925–1926, automobile and motorcycle races were run on a huge wooden track built on land now occupied by Patuxent Greens Golf Course off Route 197. Special trains that brought the crowds out stopped at Oakcrest (where Laurel Lakes Shopping Center is now) to let them off. The track specifications were so strict that the wood had to be angled exactly for speed and safety. (Submitted by Kate Arbogast, Laurel Museum director, and Elizabeth Compton of the Laurel Museum and Historical Society.)

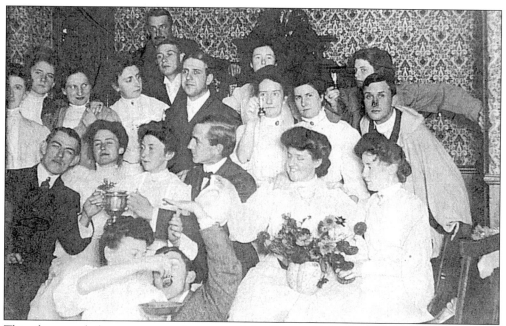

This photograph features men and women of the Tennis Club of Laurel having a celebratory party. The photograph was taken in 1900. (Submitted by Kate Arbogast, Laurel Museum director, and Elizabeth Compton of the Laurel Museum and Historical Society.)

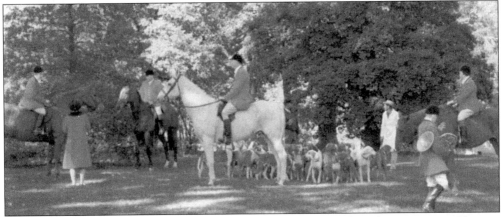

Fox hunting was popular at His Lordship's Kindness in years gone by. The mansion in Clinton, also known as Poplar Hill, was built in 1787 by Robert Darnall on land his great-grandfather Colonel Henry Darnall received in 1703. The house and grounds were bought by the Walton family in 1955. (Submitted by Friends of Montpelier; courtesy of The John M. and Sara R. Walton Foundation, Inc.)

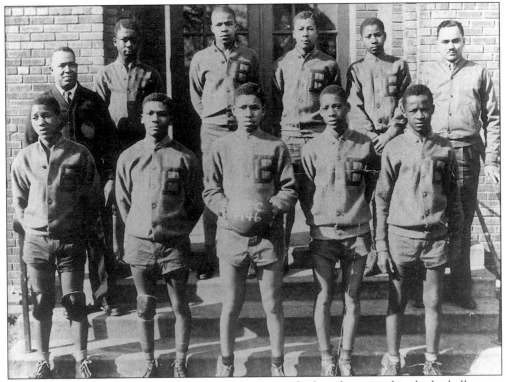

In 1946, the North Brentwood Community Center had a championship basketball team, photographed here. North Brentwood's basketball teams contributed to the town's reputation in Prince George's County and the Washington, D.C. area. Several outstanding basketball athletes from North Brentwood went on to achieve measurable success on the college and statewide levels. (Submitted by North Brentwood mayor Lillian K. Beverly; information obtained from *Footsteps From North Brentwood: From Reconstruction to the Post World War II Years* by Dr. Frank H. Wilson.)

The Ladies' Aid Society met to study the Bible and to socialize in Riverdale Park. This 1908 photograph was taken beside the Riverdale Presbyterian Church. Mrs. Viles (bottom row, sixth from left) was in charge of a children's group that met for Bible study and sewing. It has been reported that even some of the boys attended her sewing classes. (Submitted by Riverdale Park mayor Ann Ferguson from the *Town of Riverdale, Maryland 1920–70*; courtesy of Mr. and Mrs. P.W. Bixby Jr.)

Community Players offered many entertaining evenings to residents of Hyattsville. This photograph was taken following the troupe's staging of *Pirates of Penzance* on February 27, 1922 at the Hyattsville Armory. Often the Community Players' musicians and choral section were invited to use the airways of local radio stations to serenade the residents of the Washington, D.C. area. (Submitted by Riverdale Park mayor Ann Ferguson from the *Town of Riverdale, Maryland 1920–70*; courtesy of Jessie Burrhus.)

The Modernistic Social Club dressed for a gala occasion in the 1930s in North Brentwood. The club organized dances, trips, and fund-raising events. Social clubs were an important source of recreation at that time. Those pictured are, from left to right, (front row) Goldie Tilghman, Carrie Sharpes, Louise Marshall, and Ethel Thomas; (back row) Charles Bernard Tilghman, Mae Briscoe, Evelyn James, and E. Frank Marshall. (Submitted by North Brentwood mayor Lillian K. Beverly; courtesy of Earnestine Brown; information obtained from *Footsteps From North Brentwood: From Reconstruction to the Post World War II Years* by Dr. Frank H. Wilson.)

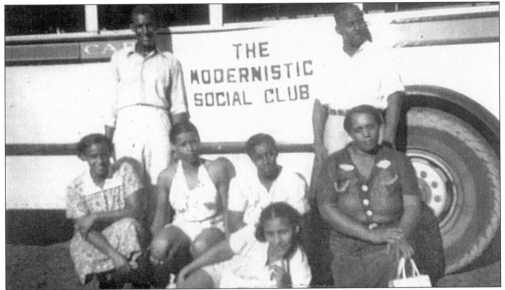

Members of the North Brentwood Modernistic Social Club would get together for different social occasions, such as this Sunday beach trip. Club members are, from left to right, (front row) Evelyn James, Myrtle Maynard, Louise Marshall, Carrie Brown, and Goldie Tilghman; (back row) Frank Marshall and Bernard Tilghman. (Submitted by North Brentwood mayor Lillian K. Beverly; courtesy of Bettye Queen.)

Mrs. Marie Walls, third from left, was known as "Mrs. Sis," the former owner of Sis's Beergarden from 1937 to 1969. "Through the 1920s, state and federal laws and temperance associations with the town prohibited the sale of alcoholic beverages. After the federal repeal of prohibition in 1933, beer gardens and taverns such as Sis's, Holmes', Stewart's, and Dock's opened." Sis's was among the best known. Bettye Queen remembers, "If you met anybody from D.C., if you said you were from North Brentwood, the first thing they would ask you is, 'Oh, you live out there near Sis's.'" Goldie Tilghman recalls that "Pearl Bailey sang out at Sis's when she first got started." (Submitted by North Brentwood mayor Lillian K. Beverly; courtesy of Bettye Queen; information obtained from *Footsteps From North Brentwood: From Reconstruction to the Post World War II Years* by Dr. Frank H. Wilson.)

Selling flowers was one way of earning some income in the country. These flowers were being sold in Broad Creek around 1915. On the left is Alice Virginia Piles Cadle (1856–1928), great-grandmother of Phyllis A. Luskey Cox of Oxon Hill, who submitted the photograph. On the right is Alice's granddaughter, Mary Belle Cadell, born in 1910, who was the aunt of Phyllis Cox.

A History of the
Bowie-Vansville Association

The Bowie-Vansville Association began in 1921 as part of a special University of Maryland project through a grant to disabled World War I veterans. The original coordinator was Agricultural Extension Agent Edward Jenkins, who did extensive work with various types of clubs and became a prominent state 4-H agent.

In the days immediately following World War I, the Department of Agriculture recognized a need to disseminate knowledge, especially about such things as food conservation and productive daily living, to the general public. Without television or much radio available, a means of doing this was through the formation of clubs, under the guidance of the Extension Service.

One such club formed by local farmers from the Bowie and Vansville voting districts was the Bowie-Vansville Association (BVA), founded in 1921 and incorporated with a state charter in 1932. The club's objectives were "to discuss the economic problems confronting the members with regards both to production and to marketing, and to make country life less monotonous, less irksome, better rewarded, and more attractive."

Early meetings were held in tents and in members' homes. Land for club use was donated in what is now the City of Greenbelt, but a lack of roads made that "garden spot of the world" inaccessible. A more suitable location in what is now the Beltsville Agricultural Research Center was donated by Lena Knauer, "The Mother of the Community," in 1929. The original plot in Greenbelt was exchanged for help with building a clubhouse at the new location in 1932.

When the U.S. government came into the area and began purchasing area farms for a national research center, more and more people sold their properties and moved away. During the Great Depression years of the early 1930s, almost everyone succumbed to the lure of urban living, as well as the need for cash. The BVA Clubhouse and the Association remained intact, though members then had to come from miles to attend meetings and functions. This is still true today, since members live from southern Prince George's up to Columbia and Gambrills.

Original activities included cooperative buying of lime, fertilizer, and other supplies, fighting with the county council about roads, and holding farm produce festivals, complete with blue ribbons and prizes. The first committees formed were the Roads Committee and the Schools Committee, both now defunct, with the Committee on Entertainment following soon afterwards.

With 50 members, they celebrated 75 years in 1996. In 1921, one of the founding members composed their club hymn. The words are still true:

> In union there is strength; we've joined our hands
> For mutual aid we've formed through fraternal bands.
> Not one for one alone, but all for all
> Each ready to respond to duty's call.
>
> May Justice hold her lamp to light our way.
> May Wisdom put her stamp on all we say.
> And may our usefulness be deep and wide
> An influence for good throughout the countryside.

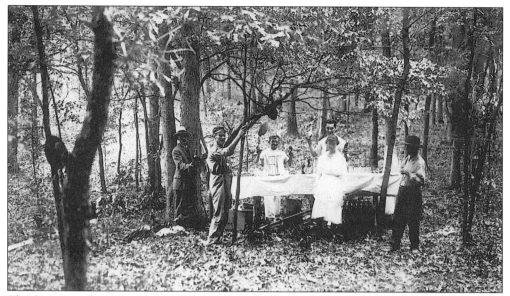

The first annual picnic of the Bowie-Vansville Association was held in 1921 in the woods of what is now old Greenbelt and the Beltsville Agricultural Research Center. Members erected a table and seating places to accommodate the picnic. Original members were farmers and country folk from the voting districts of Bowie and Vansville (Beltsville), before the U.S. government bought all their land during the Depression years to create the Beltsville Agricultural Research Center. (Submitted by Barbara Knauer Benfield, daughter of Lena Knauer, who donated the land for the clubhouse.)

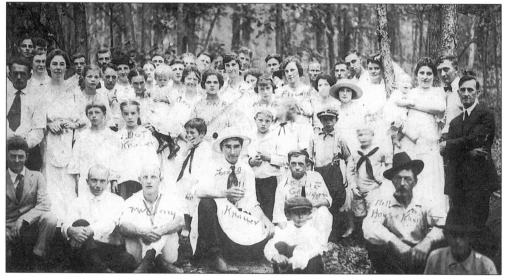

Members of the Bowie-Vansville Association are shown gathered in the woods at their first annual picnic in 1921. Some of their objectives were to "discuss the economic problems confronting the members with regards both to production and to marketing, and to make country life less monotonous, less irksome, better rewarded, and more attractive." Their original activities included the cooperative buying of lime, fertilizer, and other supplies, fighting with the county council, and holding farm produce festivals. (Submitted by Barbara Knauer Benfield, daughter of Lena Knauer, who donated the land for the clubhouse.)

Acknowledgments

Franklin A. Robinson Jr. of Benedict

Joan L. Chaconas, program assistant for the Surratt House Museum in Clinton

Mark Brady, press information officer for the Prince George's County Fire Service

Diane Cunningham, administrative aide for the Prince George's County Fire Service

Mayor Lillian K. Beverly of North Brentwood

Barbara M. Spriggs of North Brentwood

Mary R. Conner of Accokeek

Stephen Colton of Indian Head

Stephen Patrick, curator of the City of Bowie Museums

Raymond W. Bellamy Jr., town historian for Cheverly

Barbara Knauer Benfield of Landover for the Bowie-Vansville Association

Susan Reidy, historian for the Natural and Historical Resources Division of the
 Maryland-National Capital Park & Planning Commission

Susan Pearl, historian for the Prince George's County Historical Society and for the Planning
 Department of the Maryland-National Capital Park & Planning Commission

Mayor Paulette Horan of the Town of Edmonston

B. Adele Compton, CMC/AAE, clerk-treasurer for the Town of Edmonston

Ann H. Thompson of Hyattsville and the Green Meadows Citizens Association

Phyllis A. Luskey Cox of Oxon Hill

Kate Arbogast, Laurel Museum director

Elizabeth Compton of the Laurel Museum and Historical Society

Catherine W. Allen, director of the College Park Aviation Museum

Barbara Harris Herbert of Coltons Point

Nancy Thiessen of Laurel and Friends of Montpelier, also a member of the Prince George's
 County Historical & Cultural Trust

Retha Henry, president of North Brentwood Historical Society and member of Prince George's
 County Historical & Cultural Trust

Footsteps From North Brentwood: From Reconstruction to the Post World War II Years by Dr. Frank
 H. Wilson

Bill Aleshire, city councilman of Bowie

Mayor Ann Ferguson of Riverdale Park

Town of Riverdale from 1920 to 1970

Illustrated Inventory of Historic Sites for Prince George's County by the Maryland-National Capital
 Park & Planning Commission

Dr. Yvonne Seon, associate professor of African American Studies at Prince George's
 Community College and a member of the Prince George's County Historical & Cultural
 Trust

Anne Werley Smallman, curatorial intern for the City of Bowie Museums

Doug McElrath, curator of Marylandia and Rare Books for University of Maryland Libraries

Karen Thiessen, site manager for His Lordship's Kindness in Clinton

John M. and Sara R. Walton Foundation, Inc.

Sarah Bourne of College Park and the Prince George's County Historical Society

Sharon Sweeting of Hyattsville and the Prince George's County Historical Society

Smithsonian Institution

Maryland Room, McKeldin Library, Special Collections, University of Maryland Libraries

Deborah Woody, president of Green Meadows Citizens Association

James Sherriff Sr. of Oxon Hill